HORSE WHISPERINGS

BOB TABOR

ACC ART BOOKS

ISBN 978-1-85149-911-3

Published in 2010 in large format by The Antique Collectors' Club (ISBN: 978-1-85149-635-8)

This edition published in 2018 by ACC Art Books Ltd.

British Library Cataloguing-in-Publication Data:
A catalogue record for this book is available from the British Library.

Book design by Ray Benjamin

Printed in China for
ACC Art Books Ltd., Woodbridge, Suffolk, IP12 4SD, UK

www.accartbooks.com

Dedication

To my fabulous wife Randi
and my three spectacular children, Ilene, Seth and Jessica.

In loving memory of
Nancy Anholt-Tabor

OUTWARD IMPRESSIONS REVEALING INNER EMOTIONS
HORSE PORTRAITS BY BOB TABOR

Bob Tabor is a creative director and photographer who made his name with large-scale yet intimate equestrian portraits and his stunning landscape and seascape photographs. His strong graphic background allows his equine work to capture a magical intimacy.

Reflections by

Elizabeth Fagan
Psychoanalyst

Dr. Dennis Banks
Polo Professional
President of Pampa Polo Club

Carol J. Roush
Master Instructor
Equine Facilitated Human Development

Cindy Brody
Reiki Master
Creator of CinergE

ACKNOWLEDGEMENTS

A special thanks to those who whispered to me.

My caring, encouraging, beautiful wife, Randi, who gave me my first digital camera and started it all.

My children, Ilene, Seth, and Jessica for their support, excitement and energy for this book as well as every part of my life.

To my family whose whispers began before the first photo was taken. Thank you Michael Salzer, Eddie & Riva Root, Jack & Marilyn Kravitz, and Doug & Debbie Bail.

My dear friends who have my deepest appreciation for their encouragement and guidance, Ray Benjamin, Michael Somoroff, Jim Salzano, Mark Reynolds, Rick Owens, Pam Best, Robert Smith and the Pincus family - Bob, Susan, Hannah and Gabe.

I am indebted to John Brancati whose keen eye guided me through this project from the very beginning.

The digital artistry and graphic design of David Gorski and Ray Benjamin.

The writing support of Mary Helen Bohen.

And to Allan C. Schwartz, a True Collector, whose support, insight and conversations will always be a part of my life.

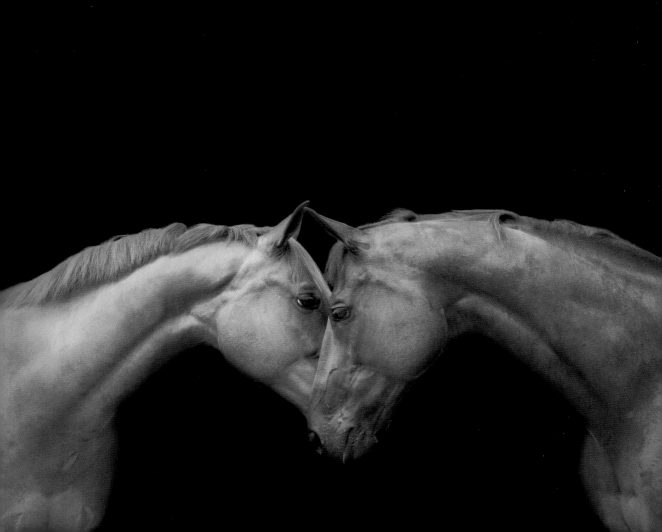

Foreword

I began my love affair with horses when I was photographing the vineyards of Sagaponack. It was not just their grace and beauty that beckoned; these animals actually spoke to me.

And I found myself listening. With camera in hand, I approached them and opened my heart, my soul, and, perhaps most importantly, my lens.

The photographs in this book reflect a unique intimacy with horses. Each portrait combines the inner strength, spirit, and gentle power of nature's most beautiful athlete.

Only natural light is used to illuminate every muscle, every hair, every sinew, as my aim was to meet my subjects on their own terms.

They, in turn, have allowed me to capture their very soul.

Bob Tabor

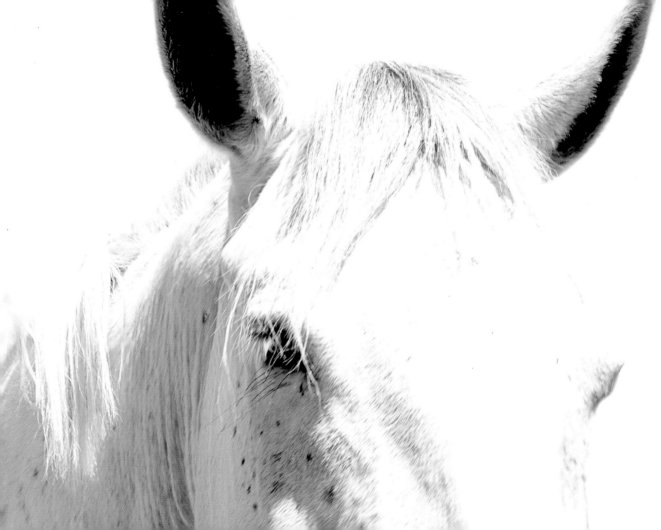

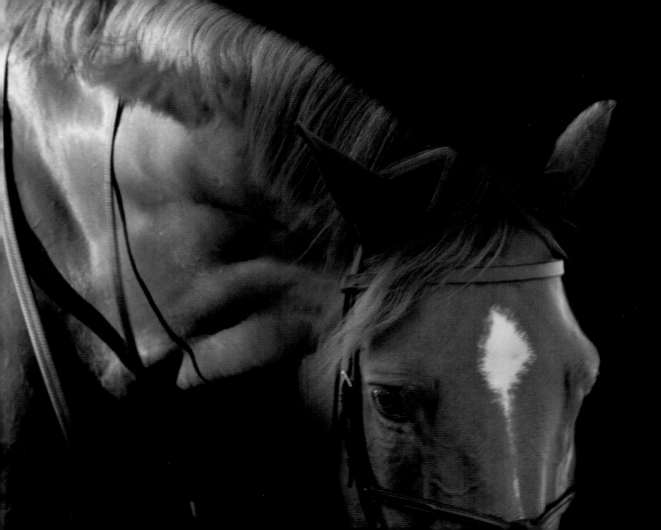

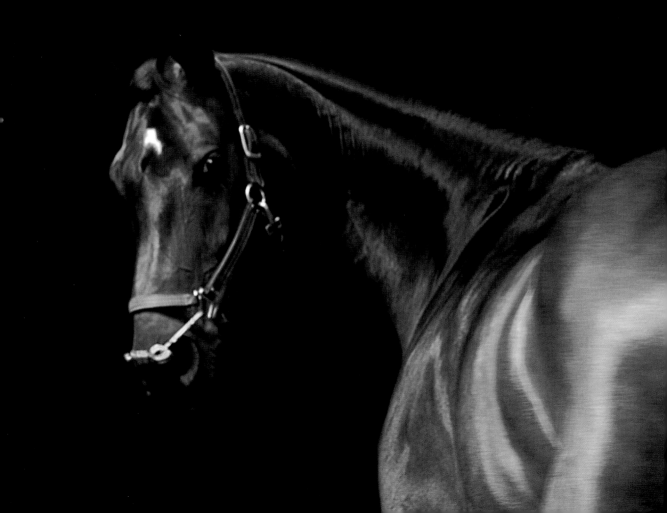

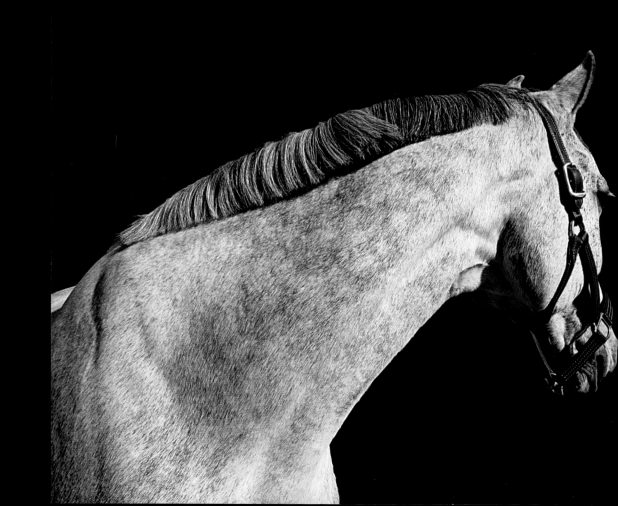

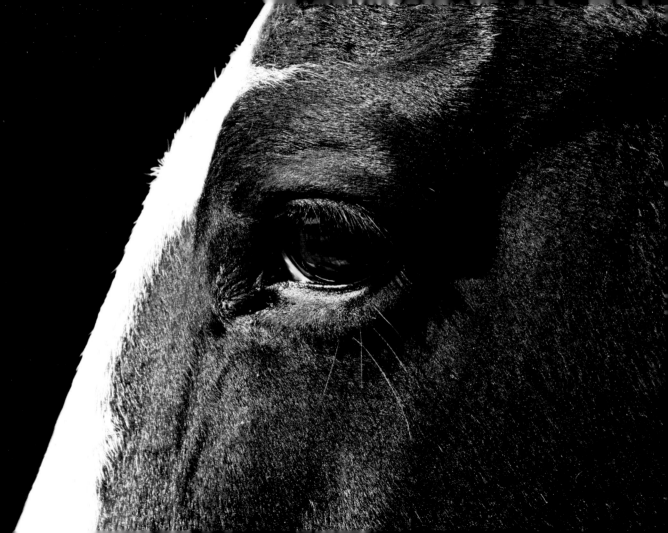

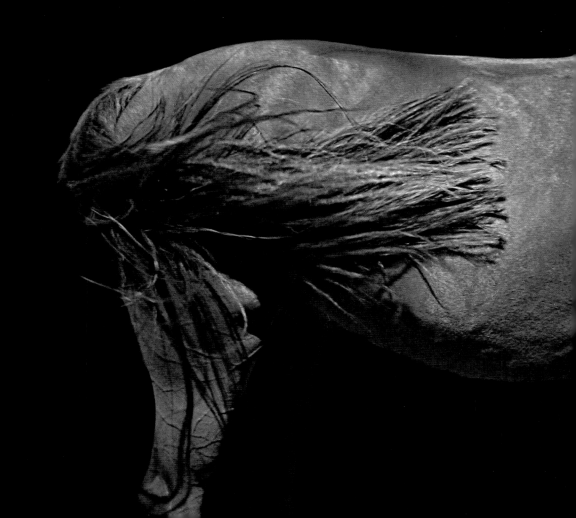

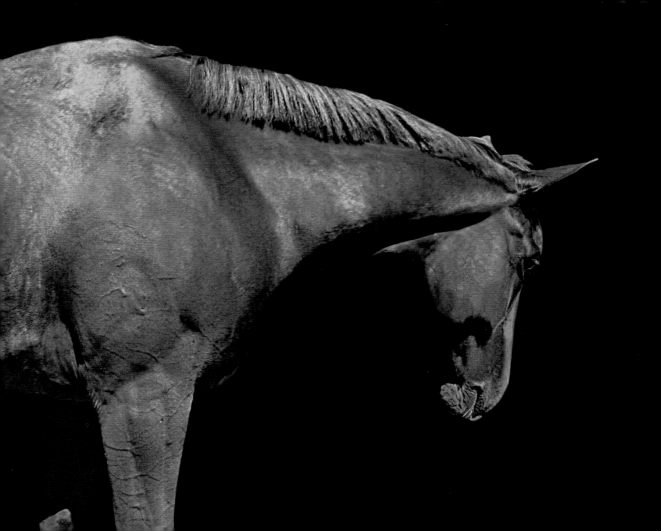

Horses have so much to tell us if we know how to listen. To hear them we must be fully present. Minds quiet, feet firmly rooted in the earth, and hearts wide open. The complete opposite of humans, horses act before they think. They do not separate the mind from the body as we humans have learned to do.

If you have ever stood among a group of horses in a field when something startles one of them, you can actually feel a wave of electricity prickle through your nervous system. You can feel the fight or flight response crackle through the air as the animals bolt to safety. They are geniuses at reading information, constantly making adjustments in their relationships.

Elizabeth Fagan
Psychoanalyst

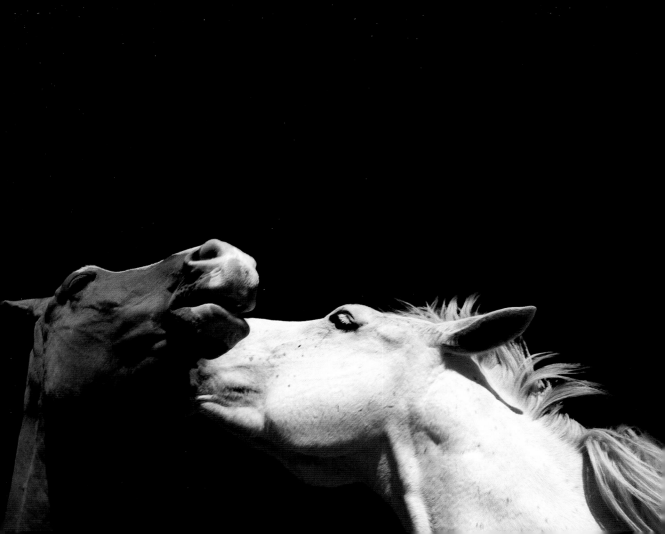

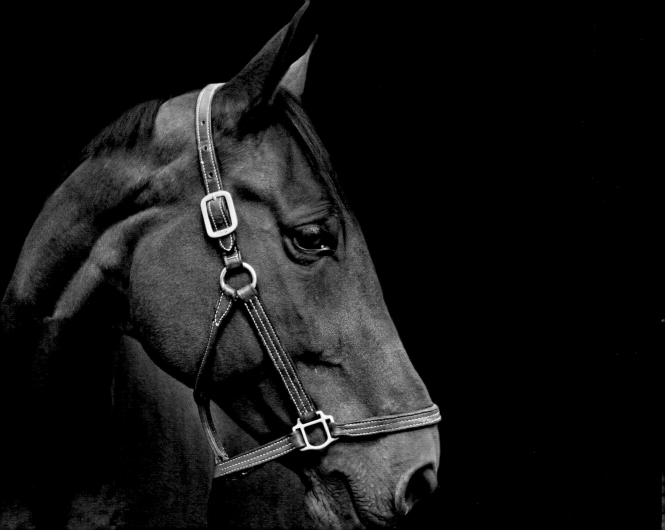

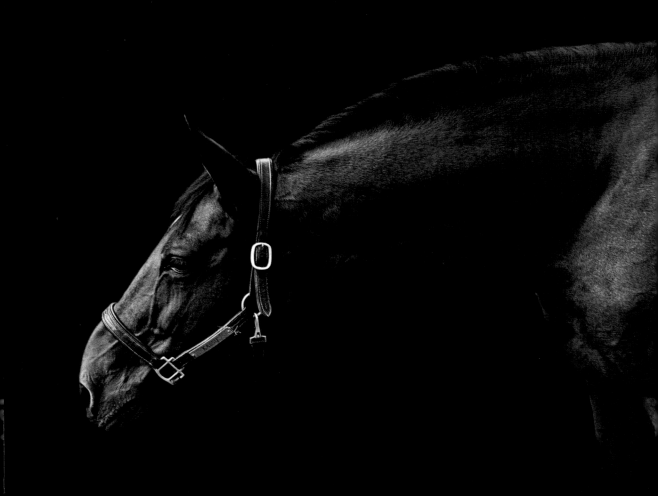

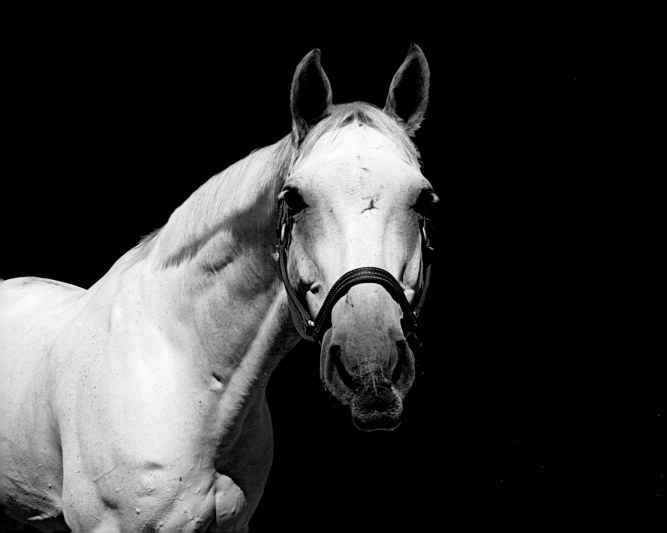

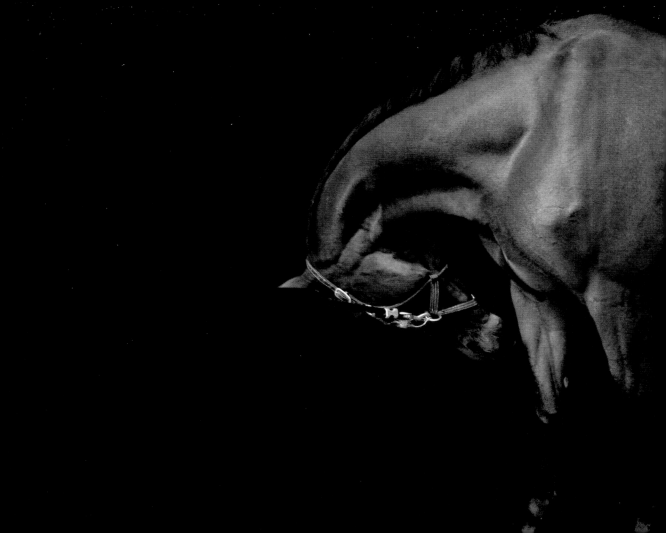

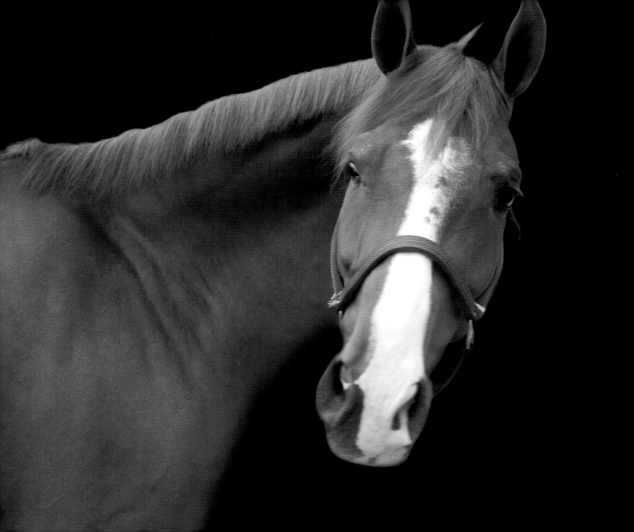

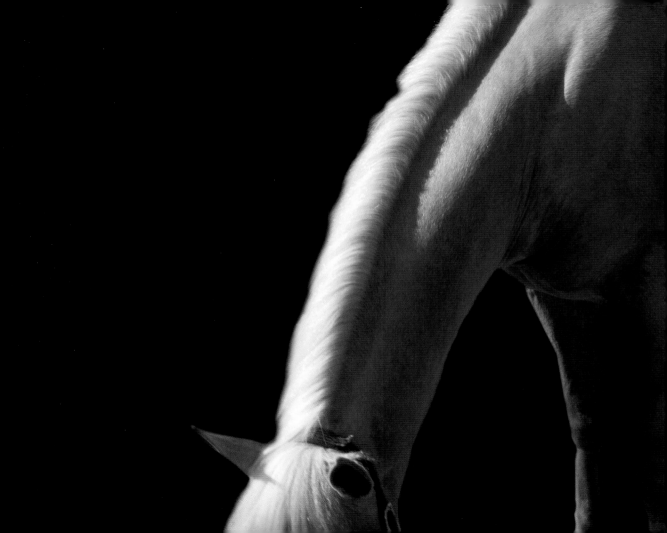

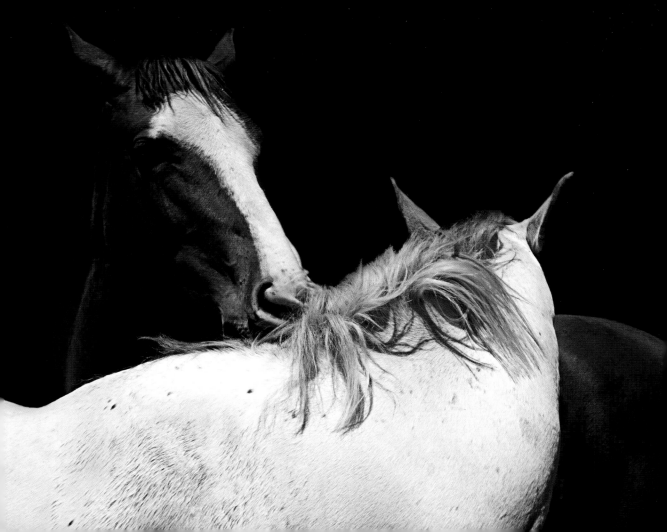

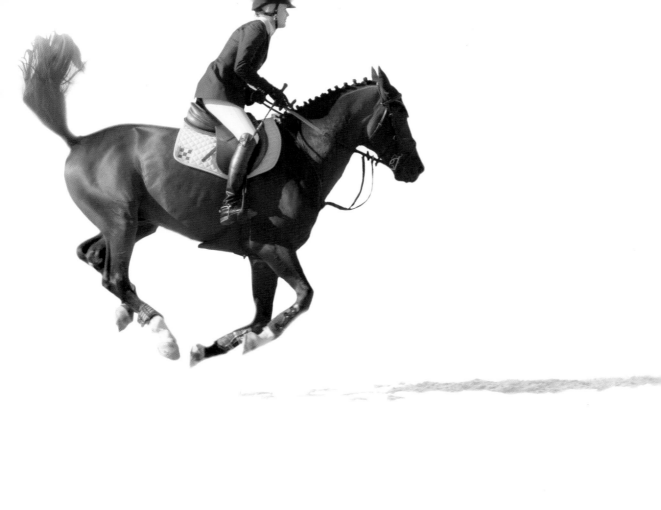

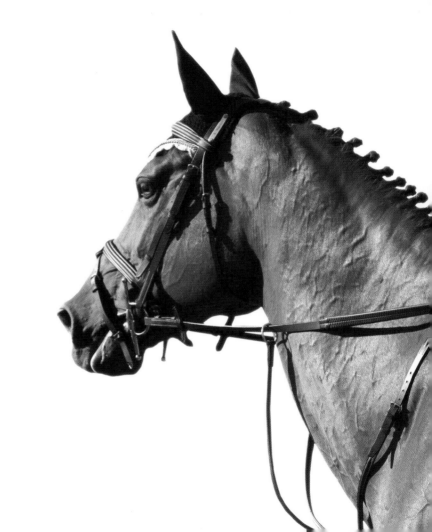

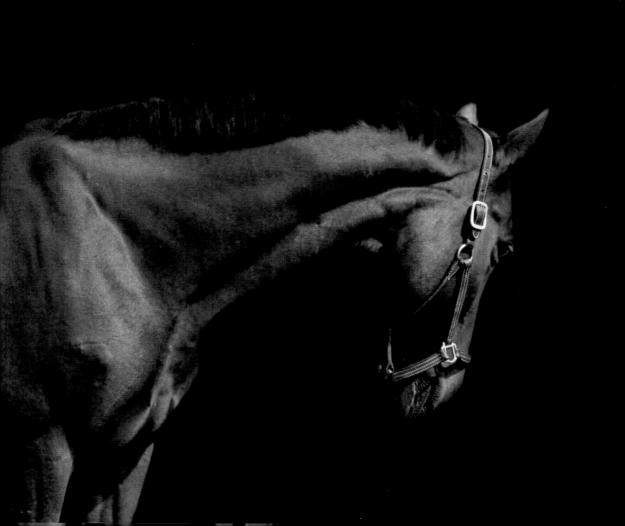

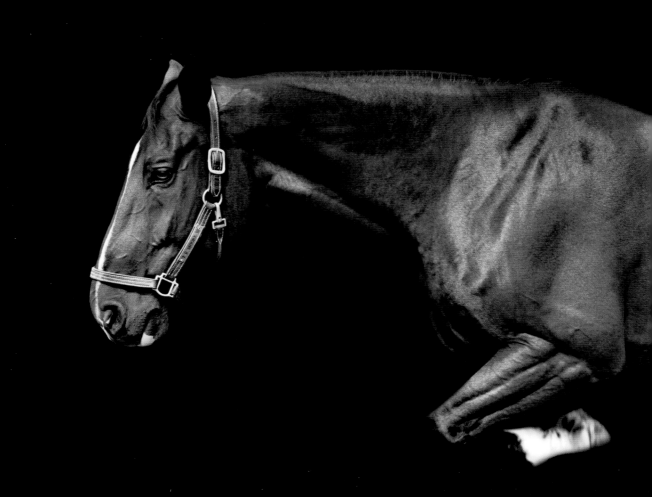

Sometimes I will get as close as I can to their great, dark, unflinching eyes. My eyes so very close to theirs, and I then stare deeply. I can see...I can feel the softness of their souls, or perhaps years of misunderstanding. I offer them my heart.

You can see if a horse is content, or frightened. They wear their emotion on their face. I can drink in their energy and be calmed, or my adrenalin will pump when they are alert to some unknown danger.

You don't need to be a whisperer to hear what they are saying. All you need to do is open your eyes, ears and heart. Horses never lie, you can see it in their eyes, they have nothing to hide.

Cindy Brody
Reiki Master
Creator of CinergE

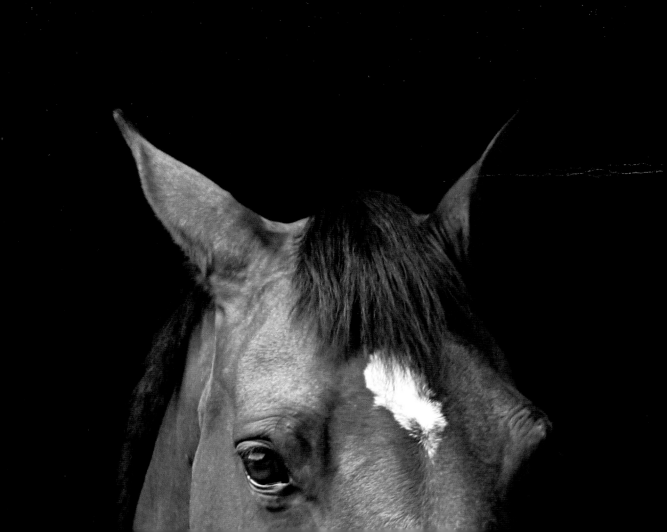

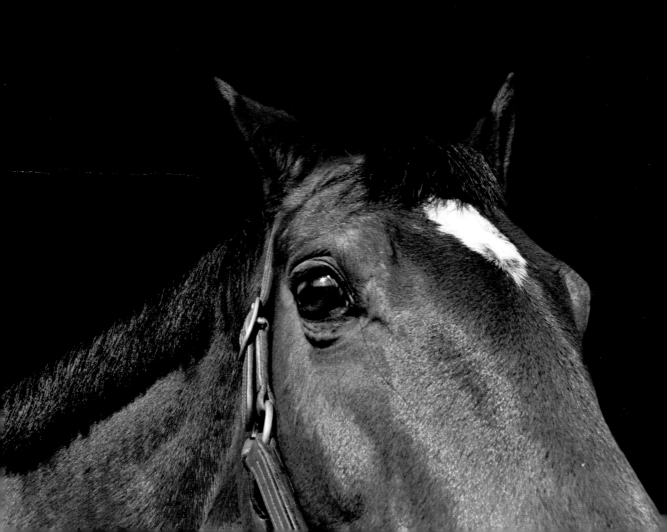

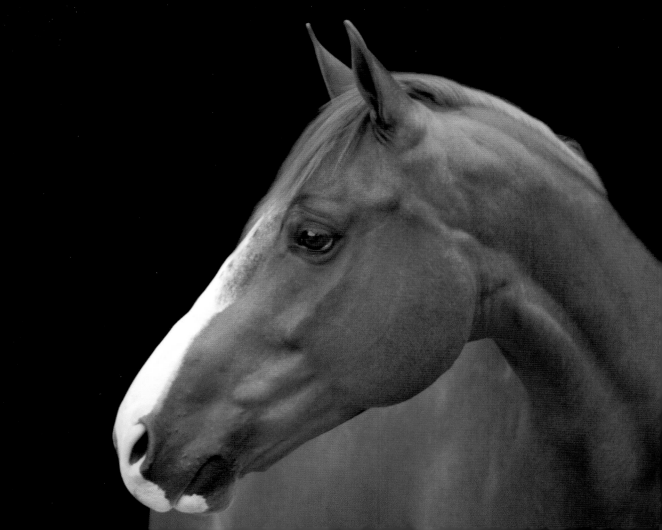

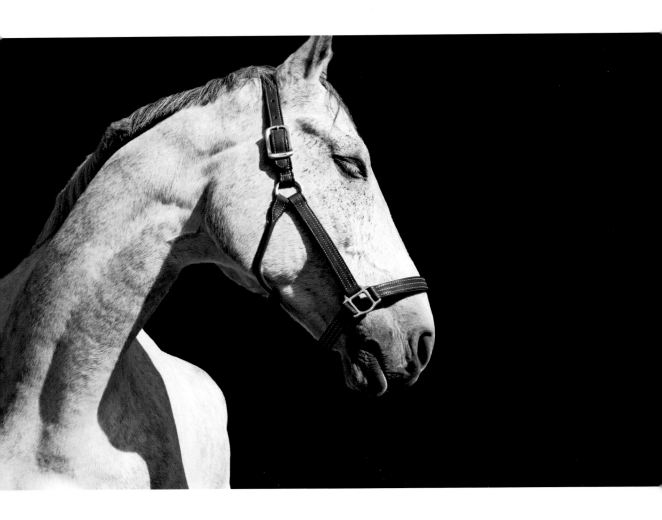

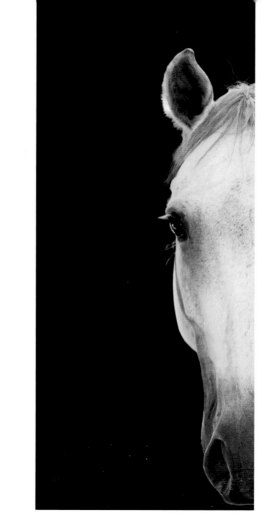

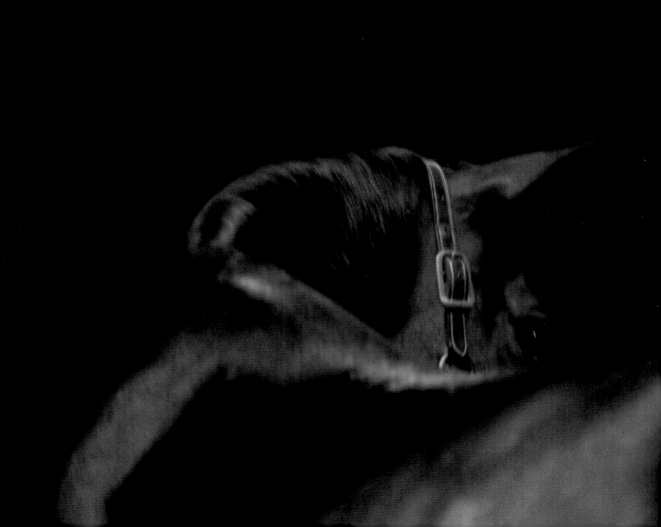

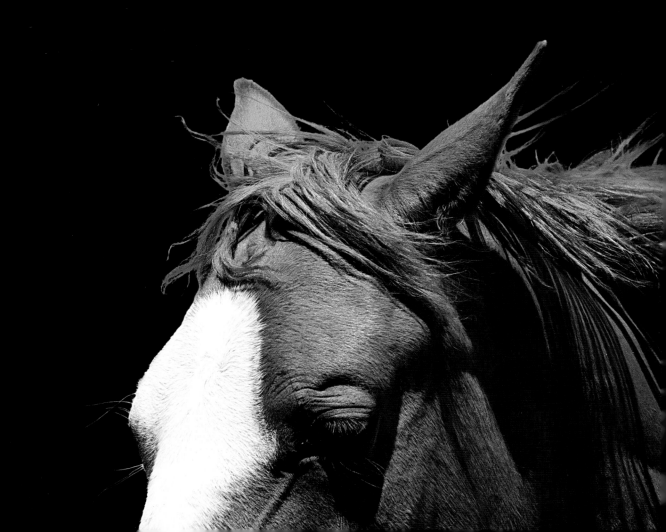

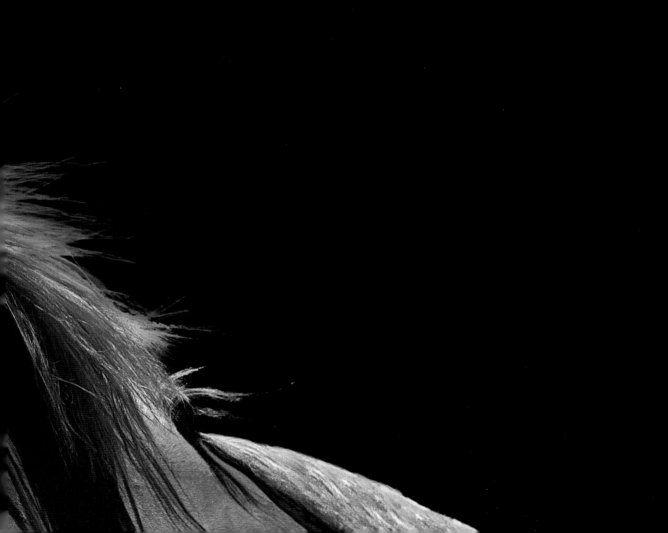

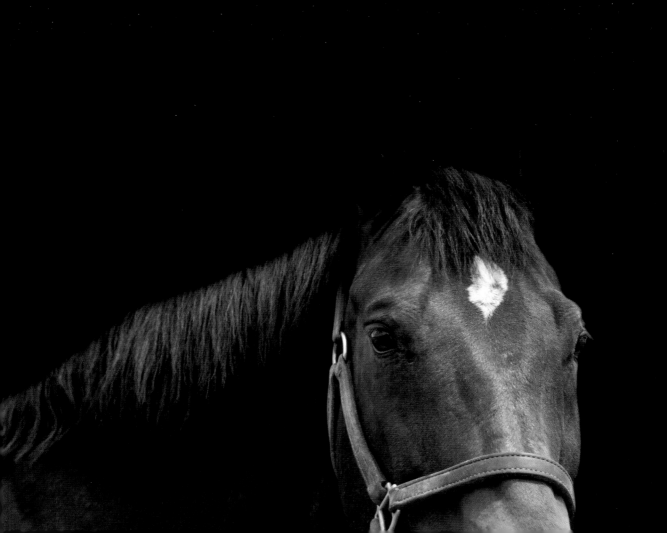

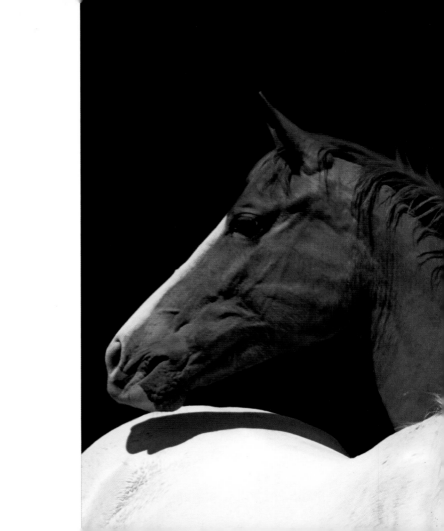

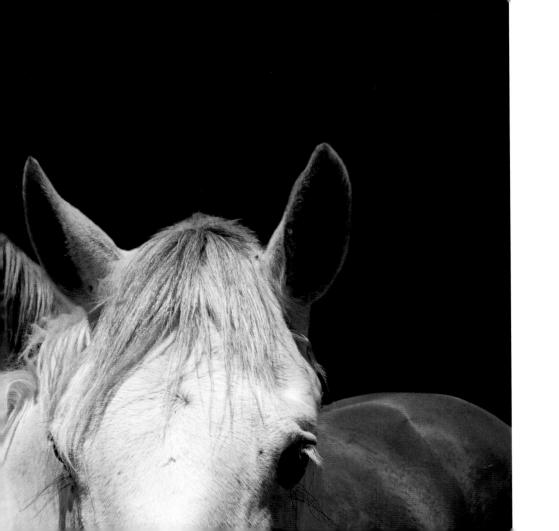

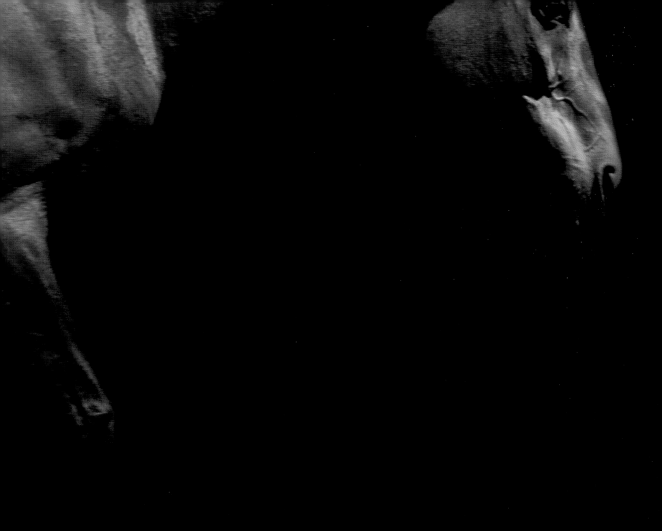

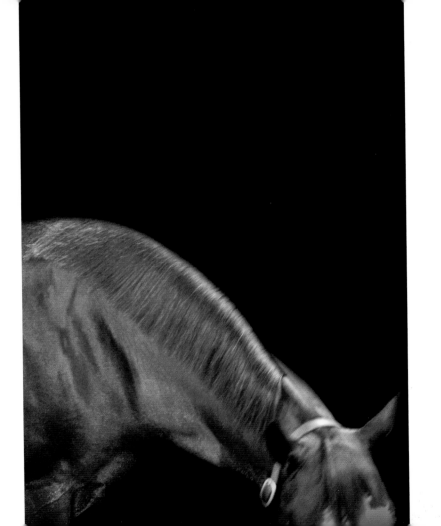

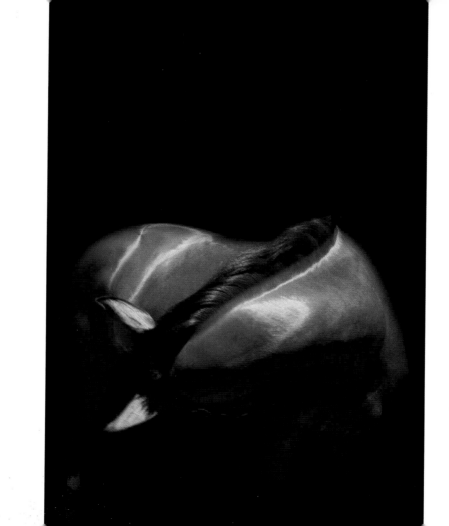

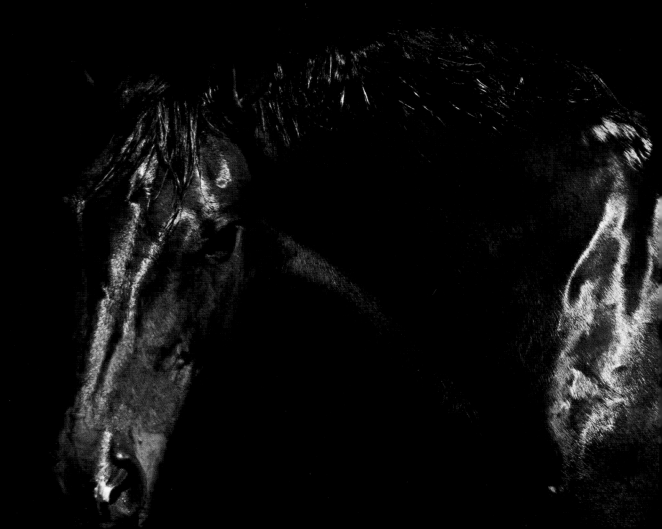

I have watched a patient of mine, a young girl, reconnect with what she calls her true self. She was working with a retired show pony called Bright. My young patient began a nonverbal dialogue with Bright, being careful to approach her slowly and stop when she noticed tension in Bright's body or posture.

Eventually, Bright let the girl come close and pet her. But what affected my patient most was how she felt when she stepped back a few feet from the pony. Respectful and sensitive to the pony's nonverbal communication the girl heard the message Bright was sending her. She instinctively knew that while Bright tolerated the touching, the deeper layer of connection was at a distance that allowed both horse and human to have the space they required to feel safe, seen and known. She stepped back. Bright then turned toward the girl and welcomed her attentions. In turn, the girl felt at one with herself and in this intimate connection with another being.

Elizabeth Fagan
Psychoanalyst

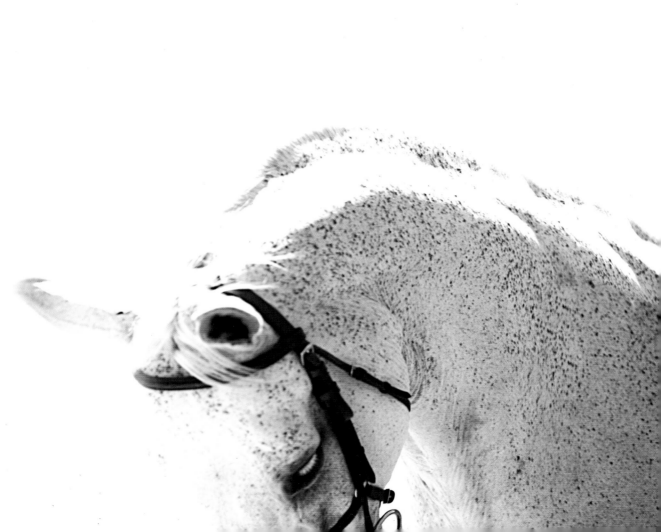

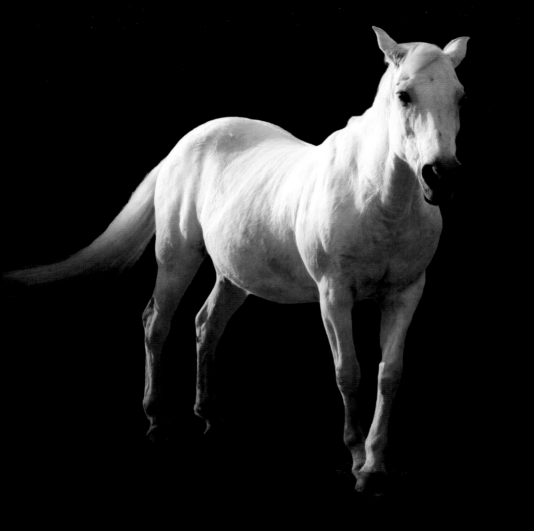

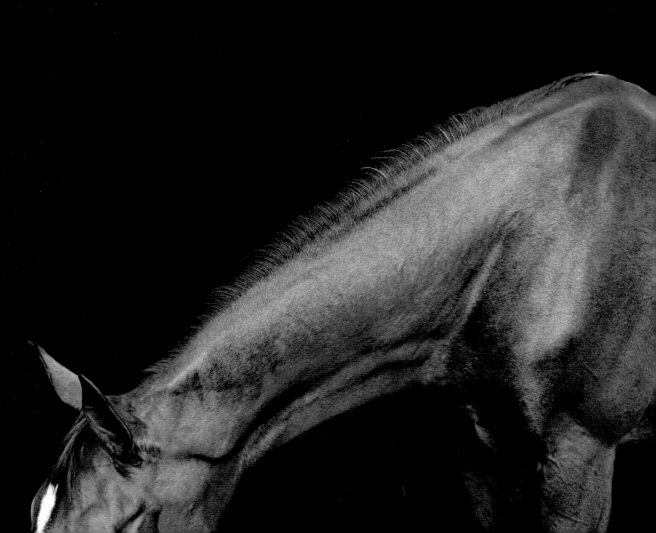

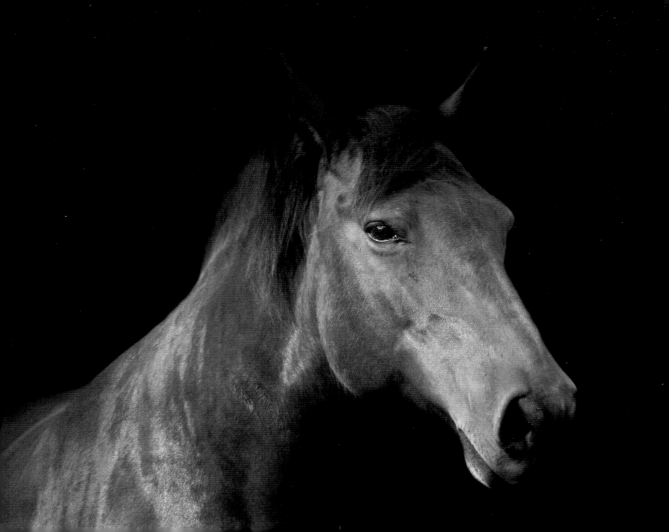

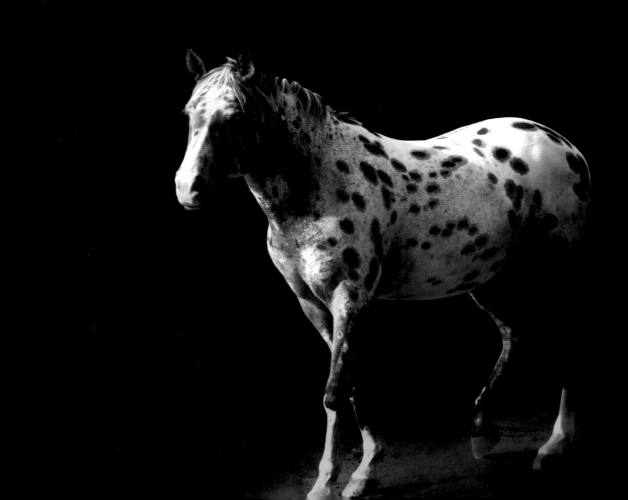

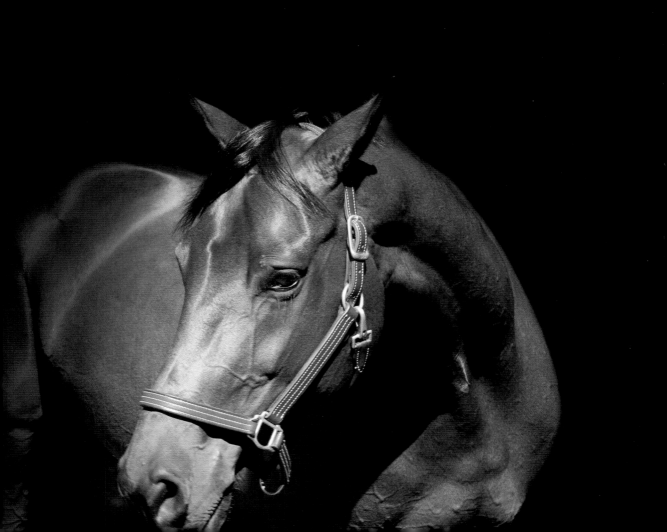

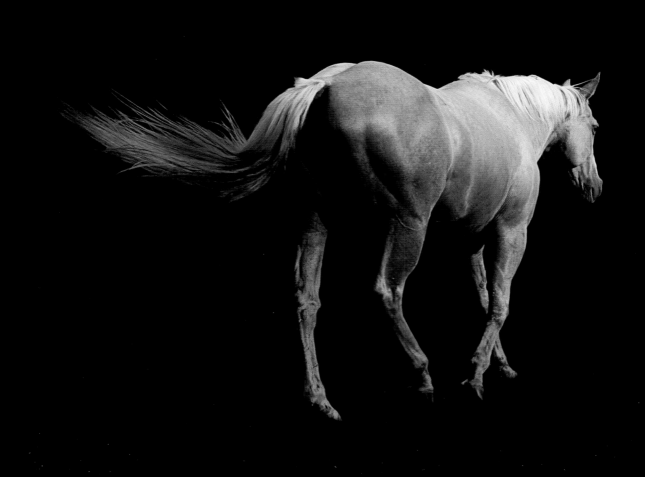

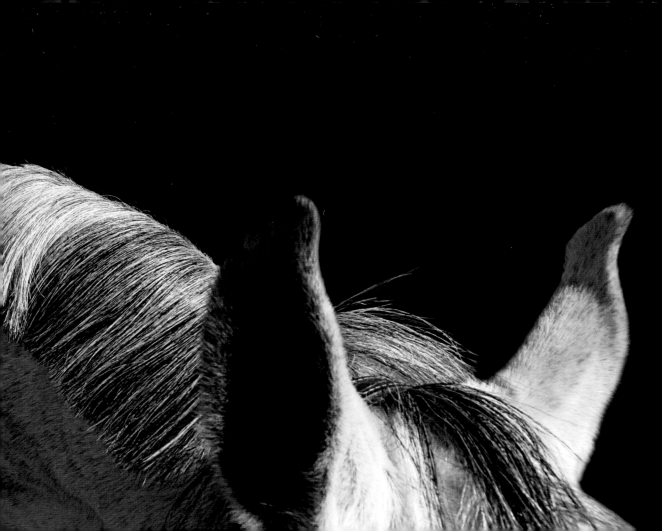

The ancient use of the horse was for military purposes. Nowhere is this clearer than on a polo field. From the perspective of the horse, he is going into battle against seven other horses and riders. To clash, bump, outrun, stop faster and turn more quickly than his opponent's horse. This athleticism and psychological attack mode poses a tremendous challenge to the horse and is the antithesis of his very nature – which is to avoid confrontation and live harmoniously with other horses.

Dr. Dennis Banks
Polo Professional
President of Pampa Polo Club
East Hampton, NY

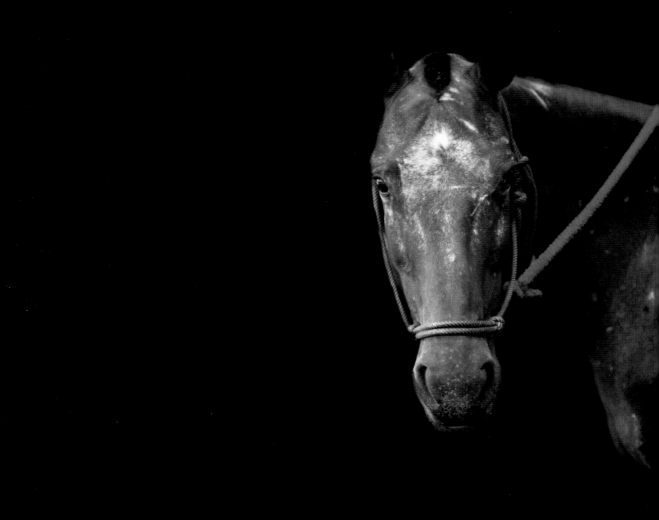

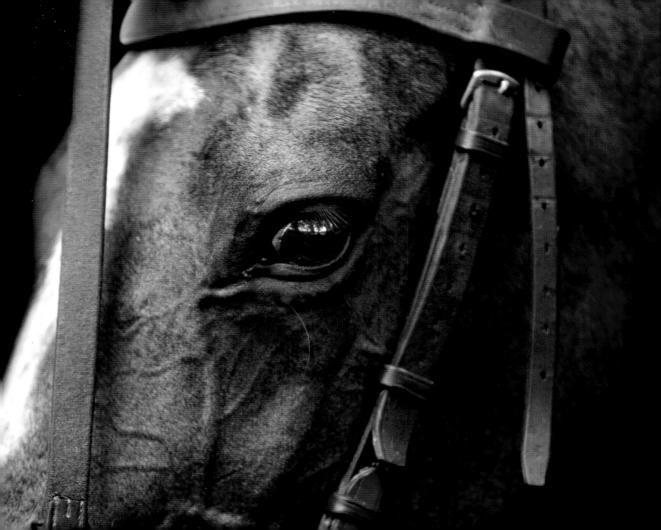

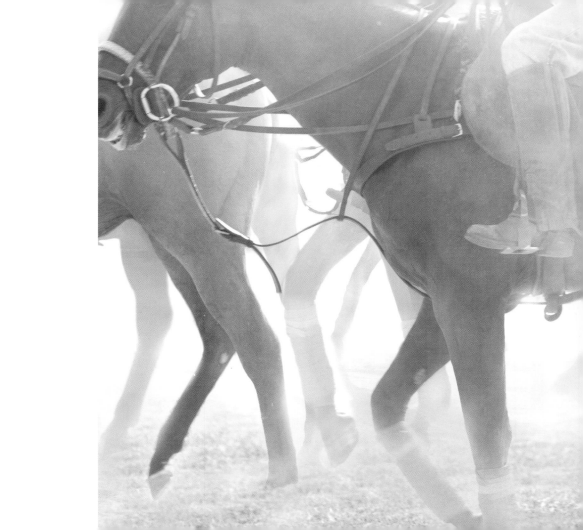

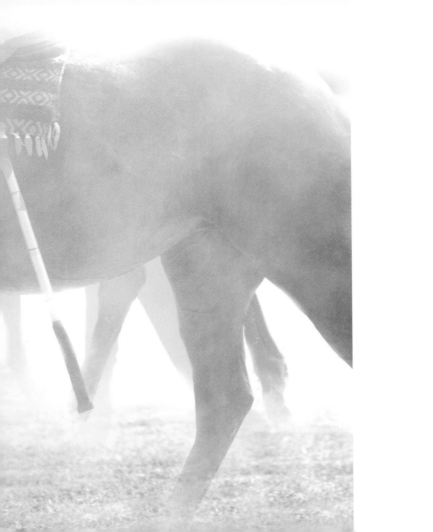

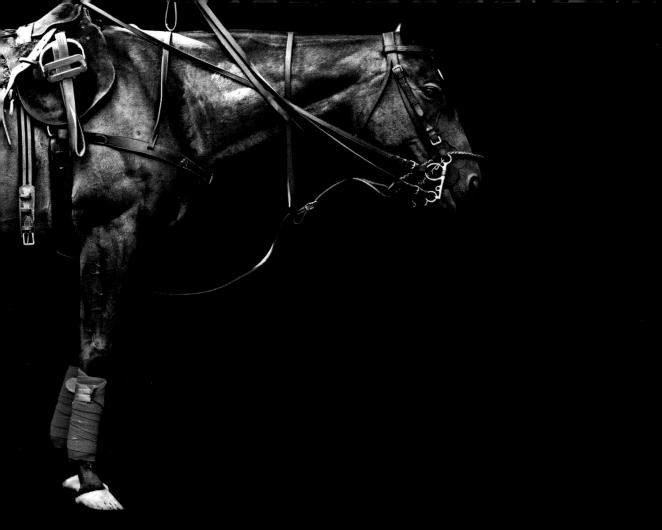

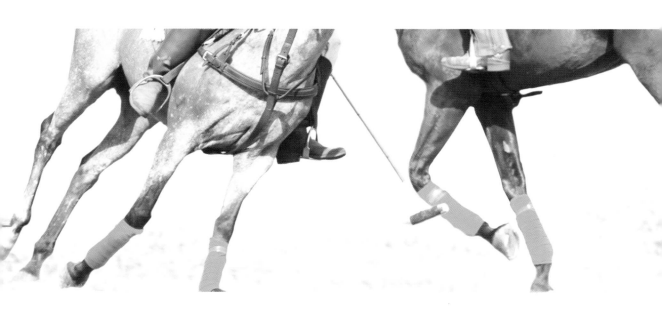

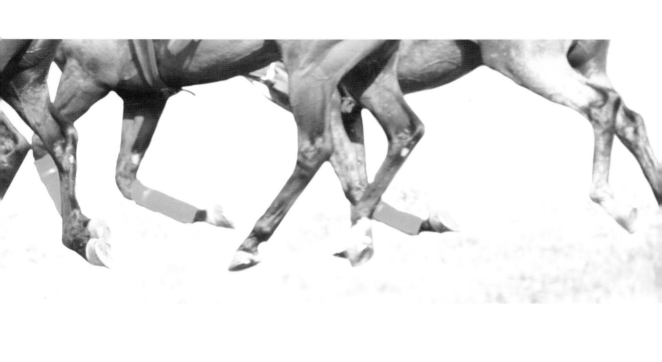

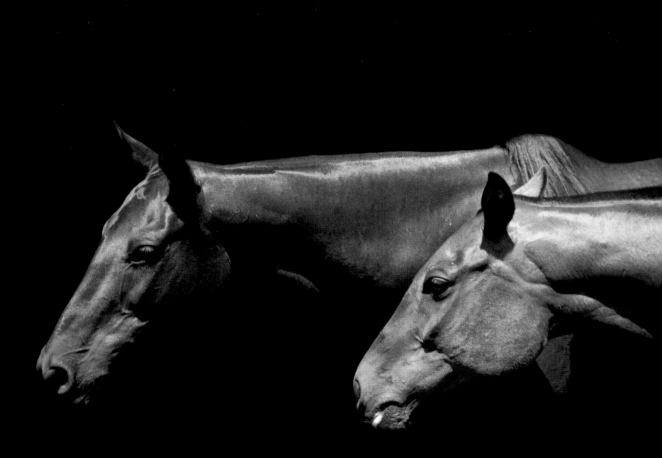

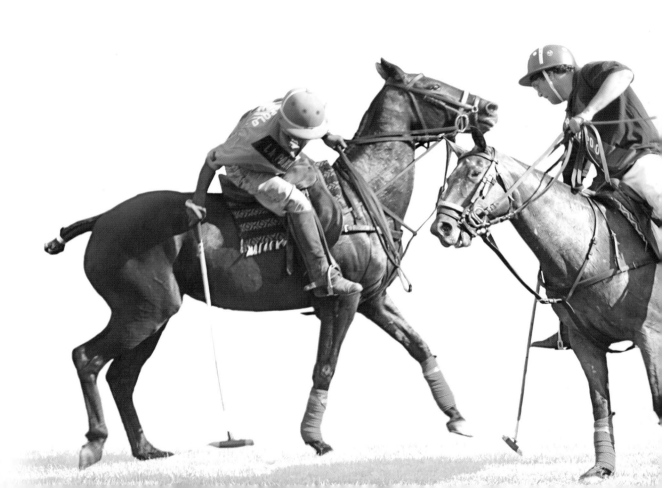

Why does the horse permit us to throw a saddle on his back and put a bit in his mouth?

I believe it is as simple as a "deal" that has developed over time:
I'll take care of you, horse, if you take care of me. I'll see to it that you are fed and kept warm and clean, I'll give you kindness and respect. You, in turn, will do as I ask in as much as you feel it's fair and within your capacity to give. We will protect one another.

If the deal is apparent to both sides, there is no reason for mistrust. Therefore, the horse, in general, will do as you ask. That is essentially the depth of the understanding. We have more than a meeting of minds. We have a meeting of hearts.

<div align="right">

Dr. Dennis Banks
Polo Professional
President of Pampa Polo Club
East Hampton, NY

</div>

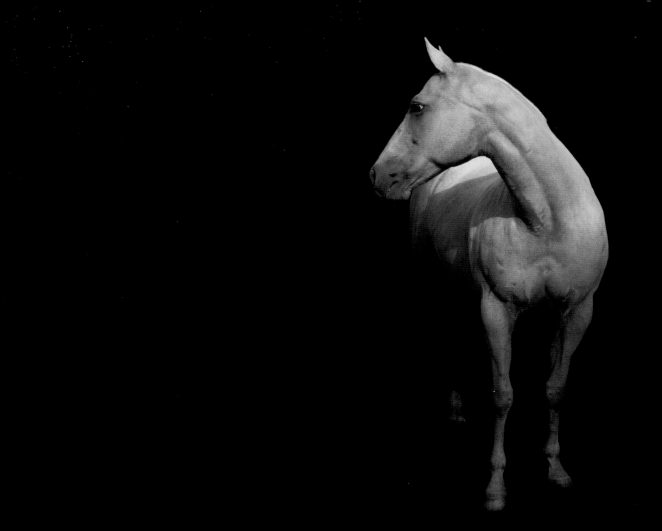

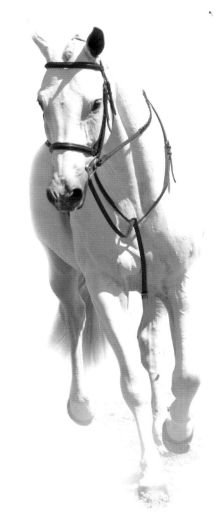

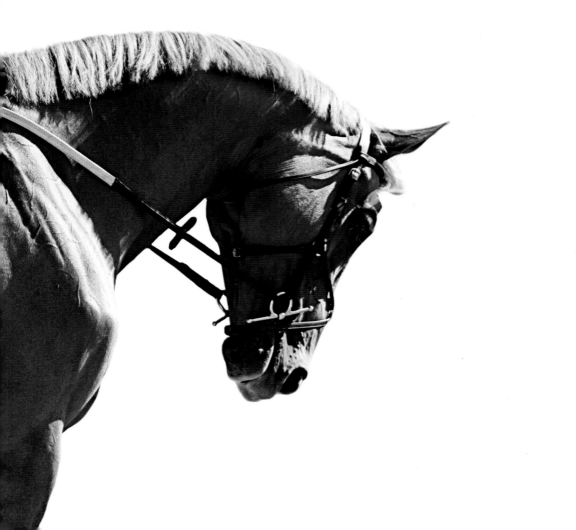

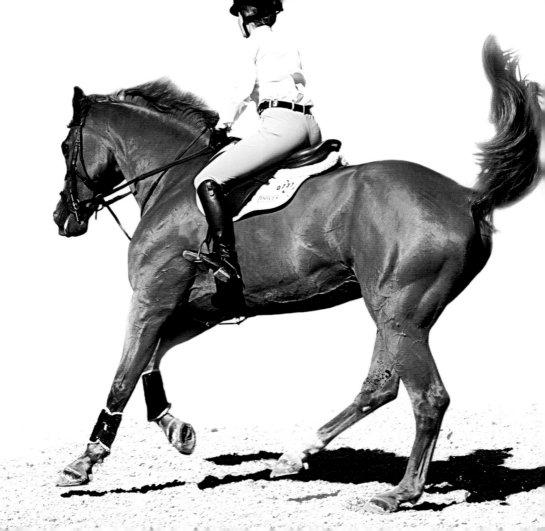

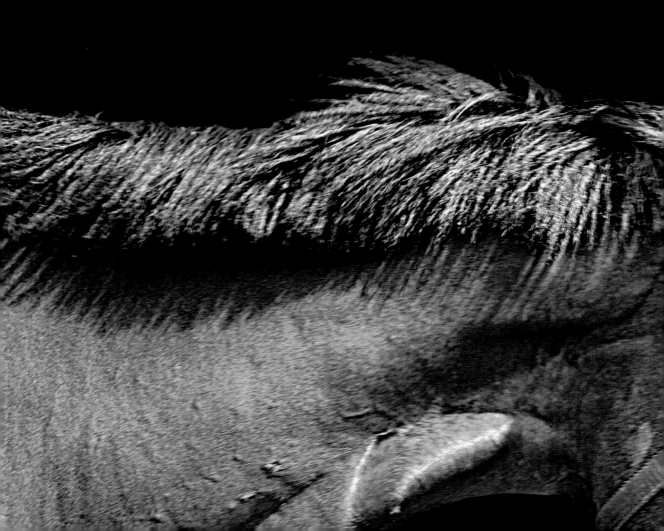

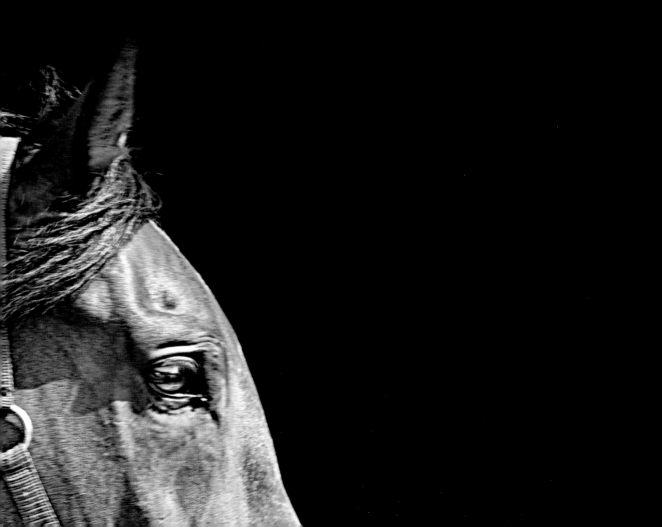

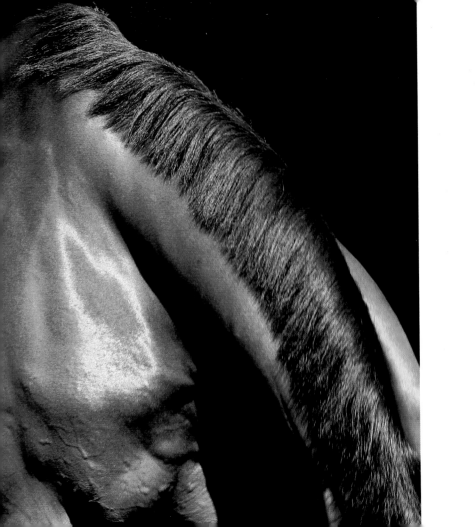

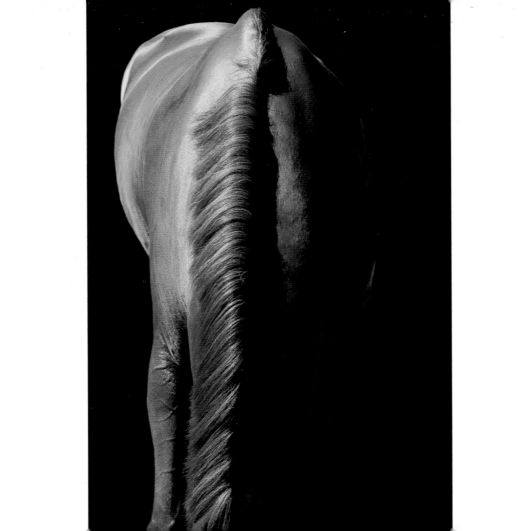

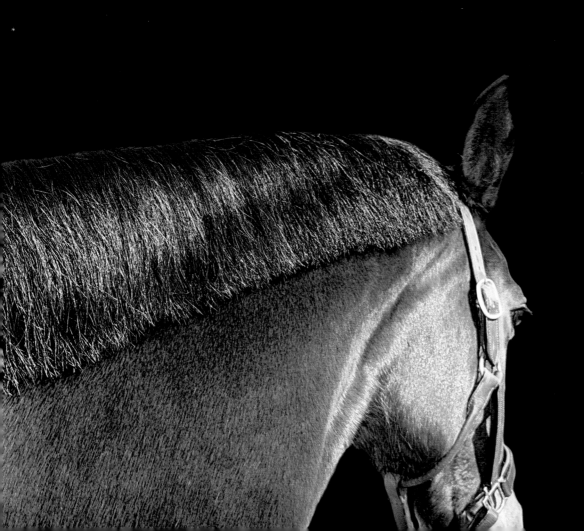

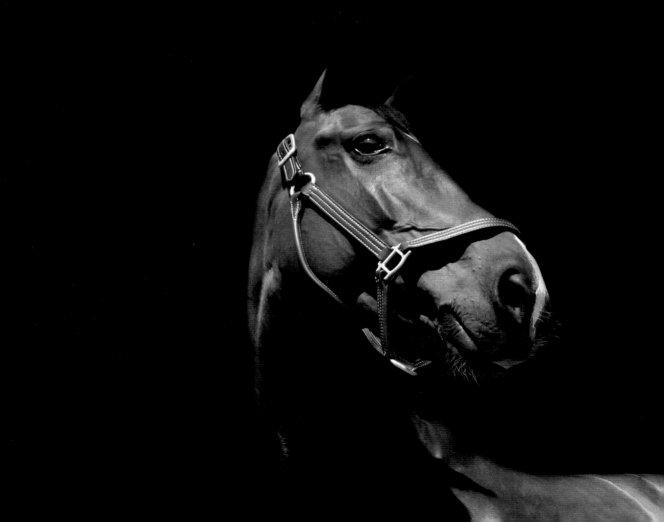

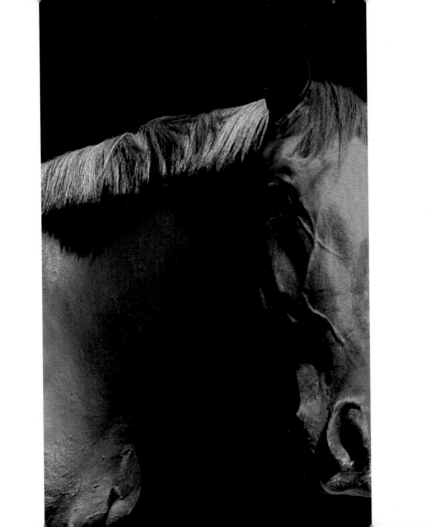

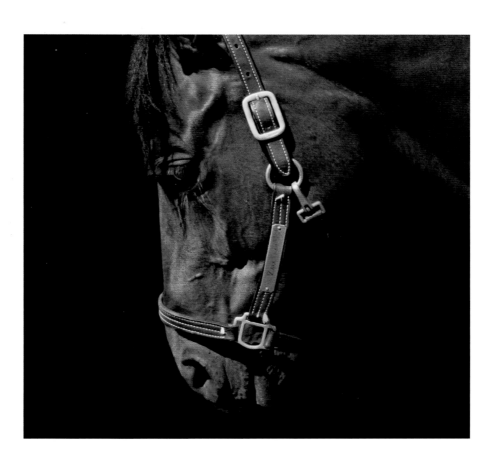

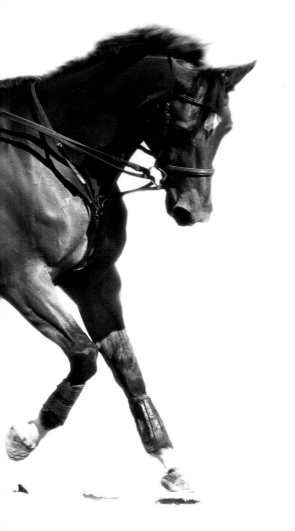

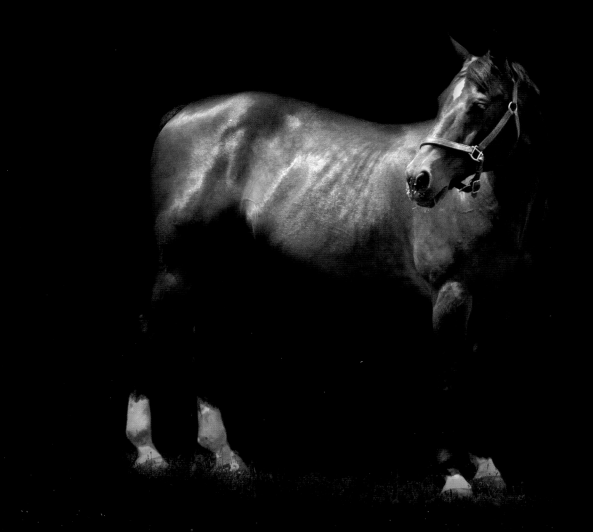

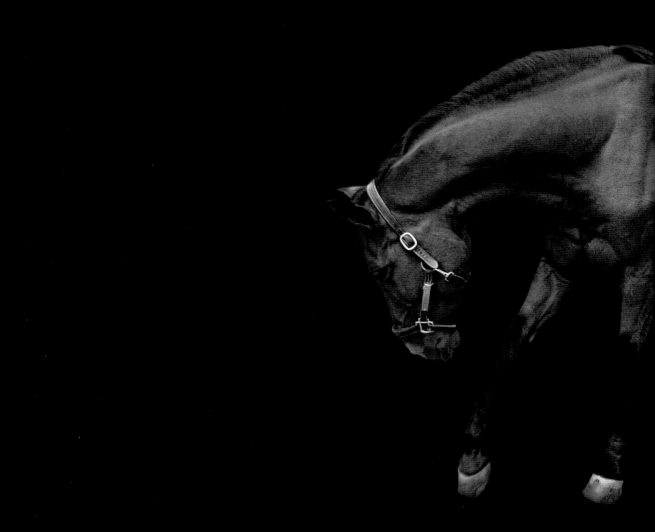

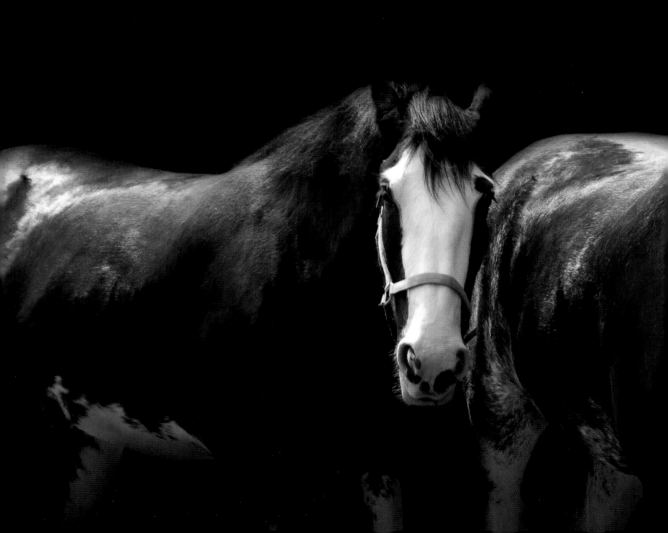

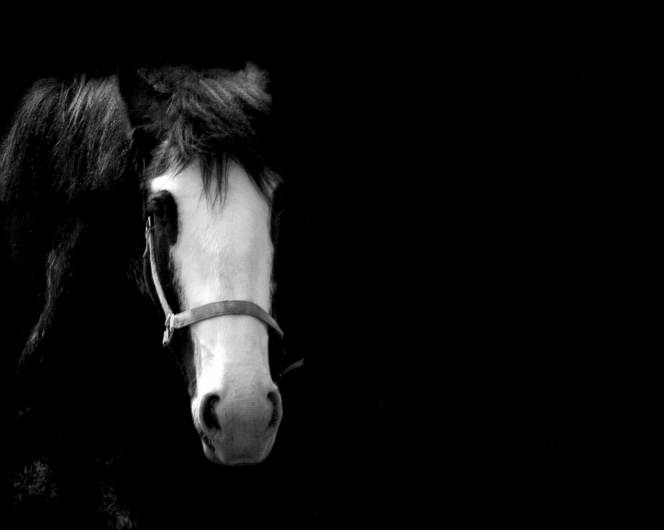

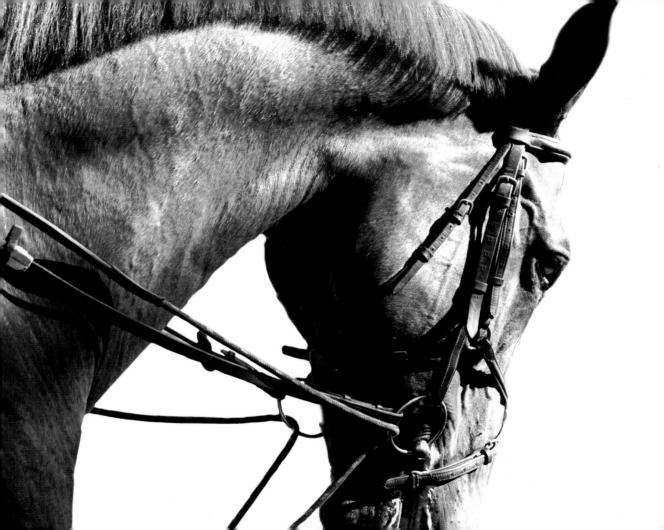

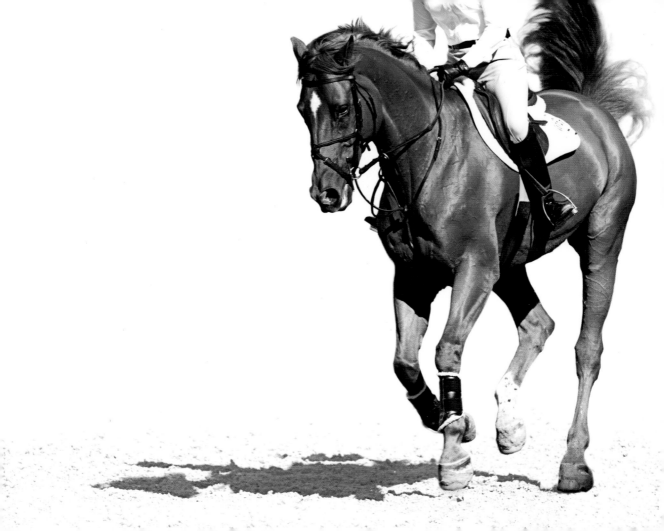

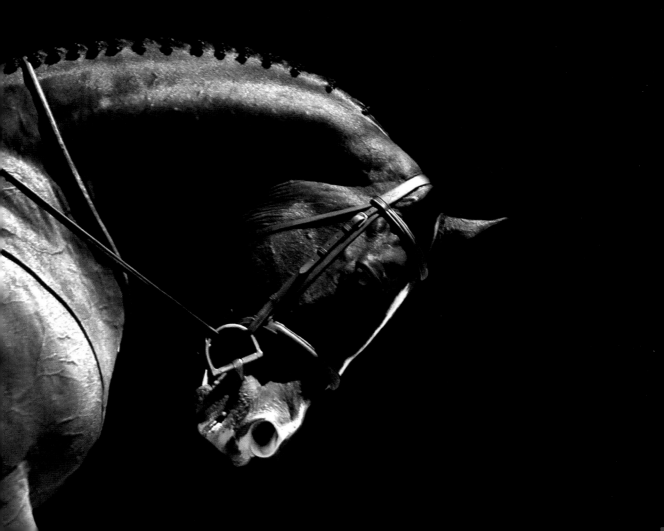

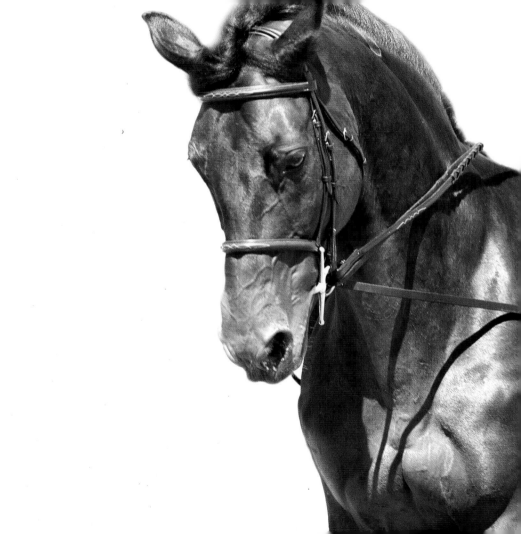

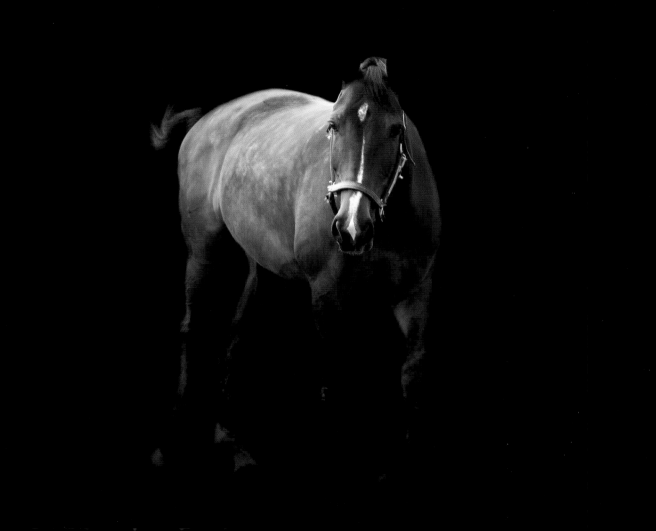

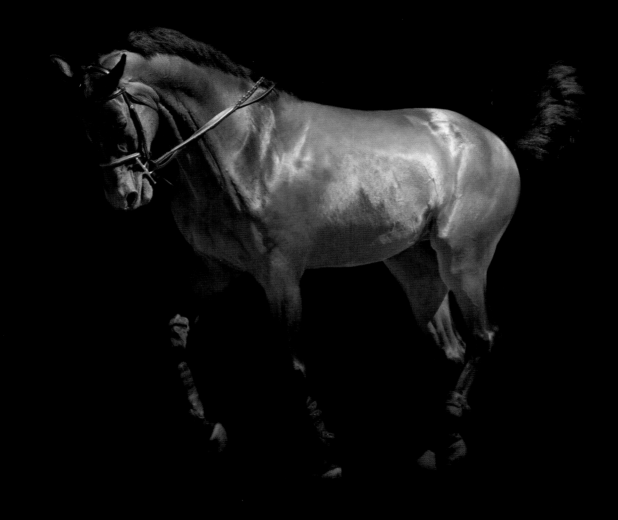

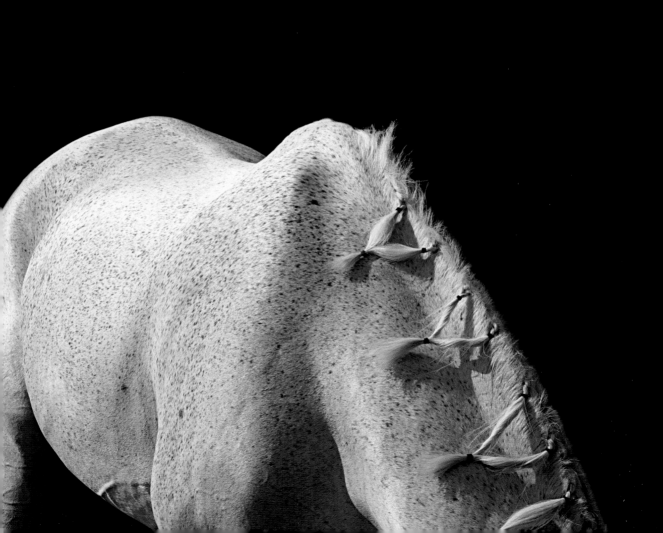

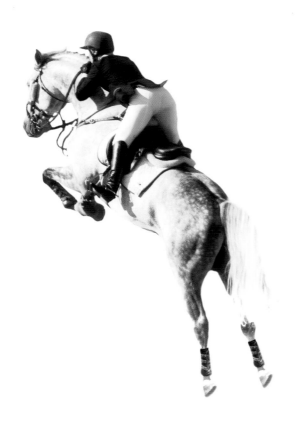

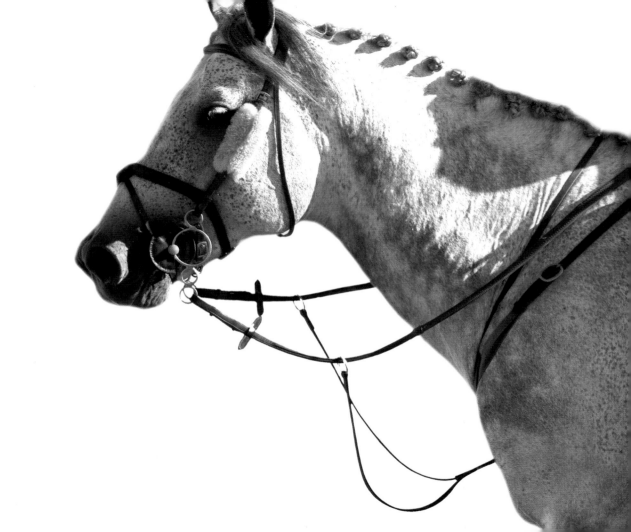

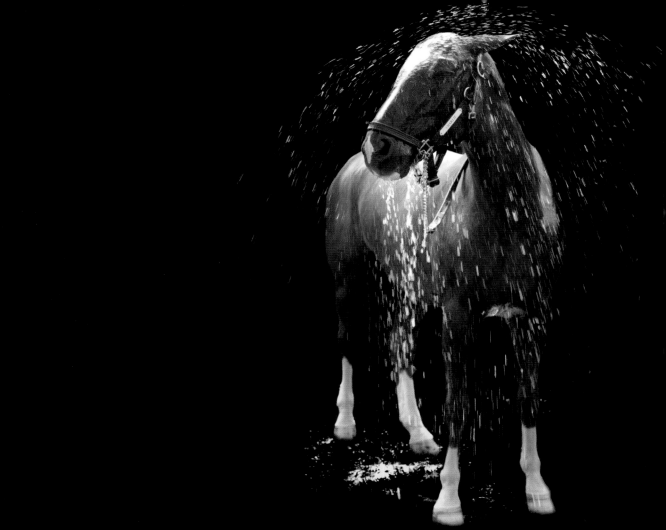

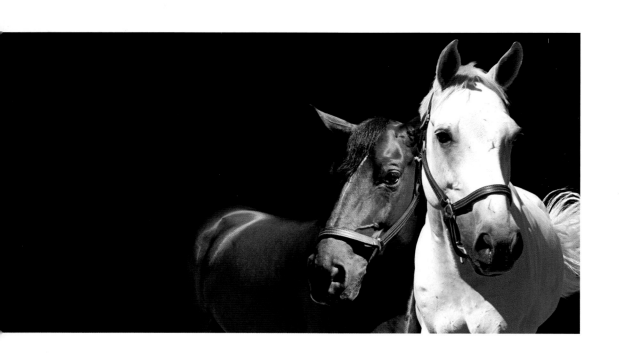

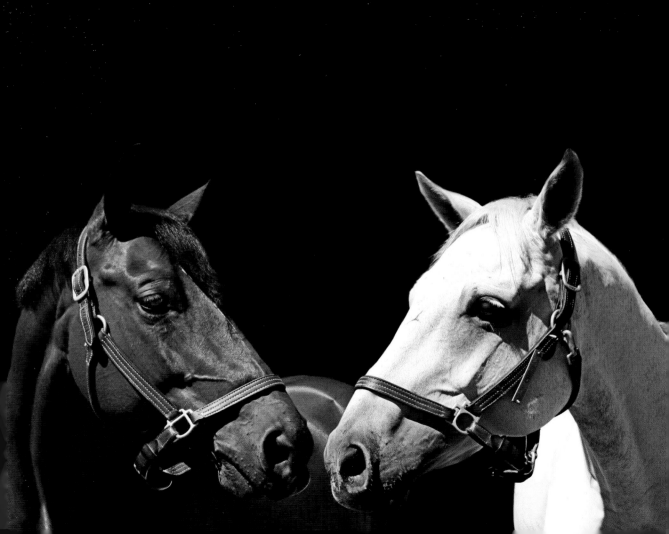

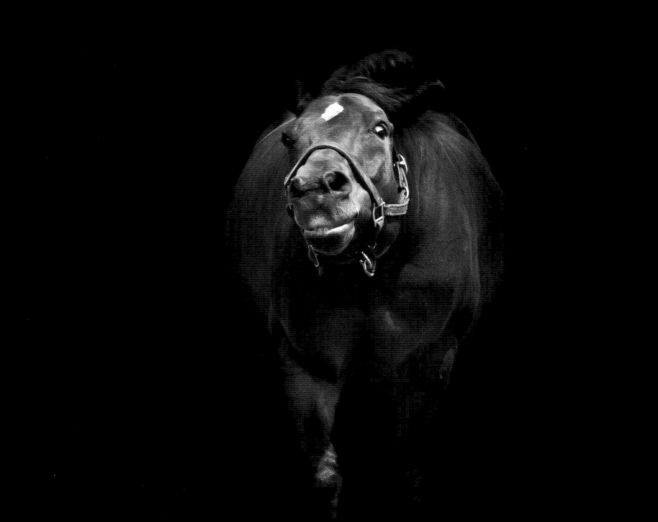

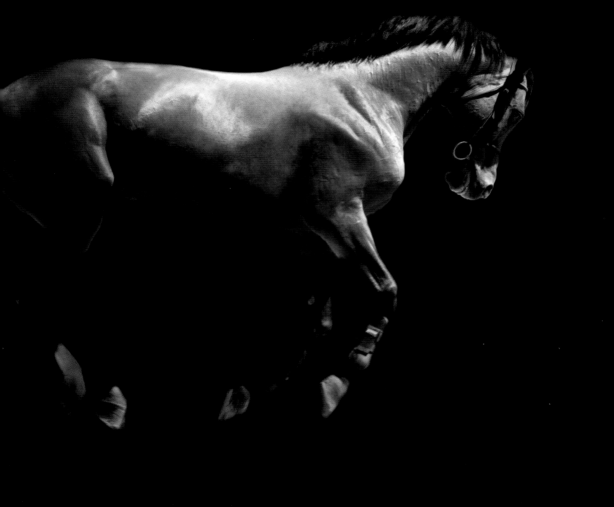

I wonder sometimes if autistic children intend, prior to their arrival on Earth, to advance the evolution of humanity by refusing to be squeezed into the existing molds that most "normal" children are forced to endure. This process, called domestication by many wise spiritual teachers, is one that horses have spent thousands of years gently leading man away from. We somehow come to believe that a rigid comfort zone of neutral emotion is the preferred state of existence. Reclaim your freedom, the horses seem to say, and dance with all the emotional richness life has to offer. Without the dissonant notes, harmony has no meaning. Soar with joy, without fearing the plunge into sorrow that may follow, knowing that love will pick you up and carry you to peace. All this and more I have seen in the soft and gentle eye of a horse.

Carol J. Roush
Master Instructor
Equine Facilitated Human Development

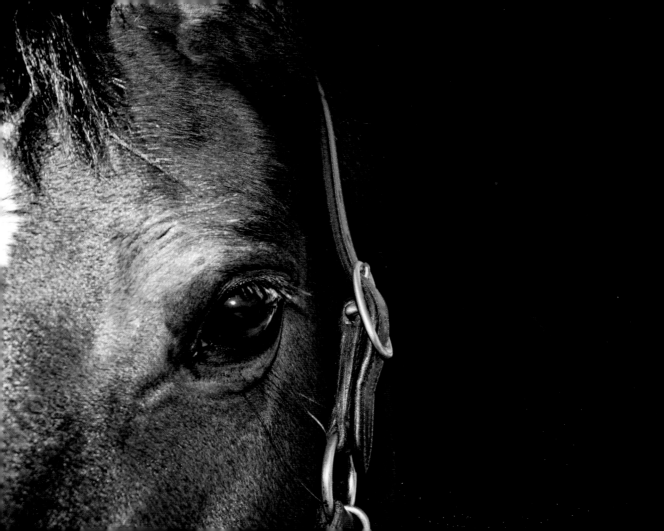

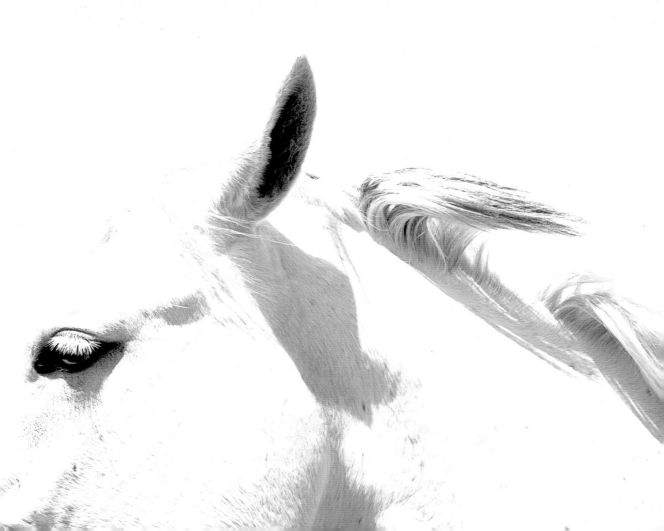

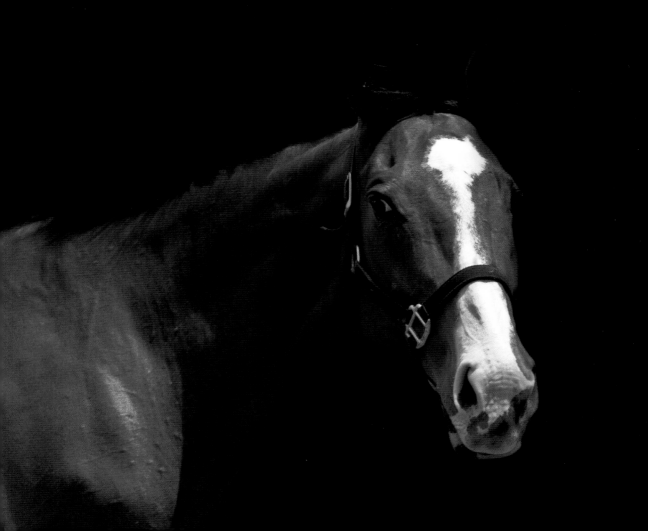

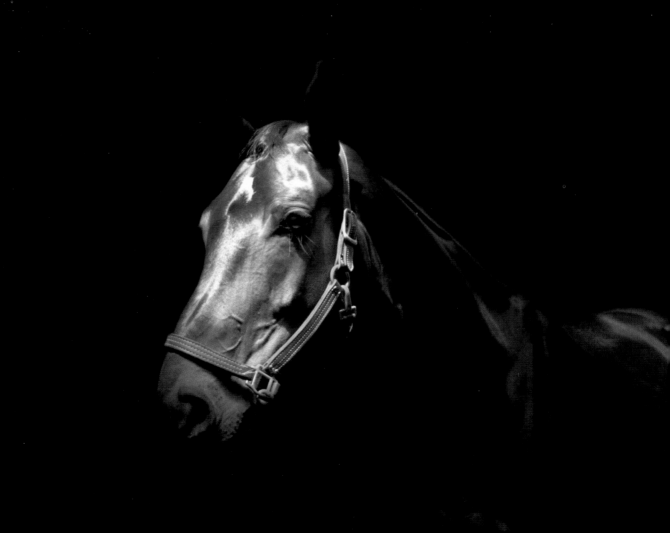

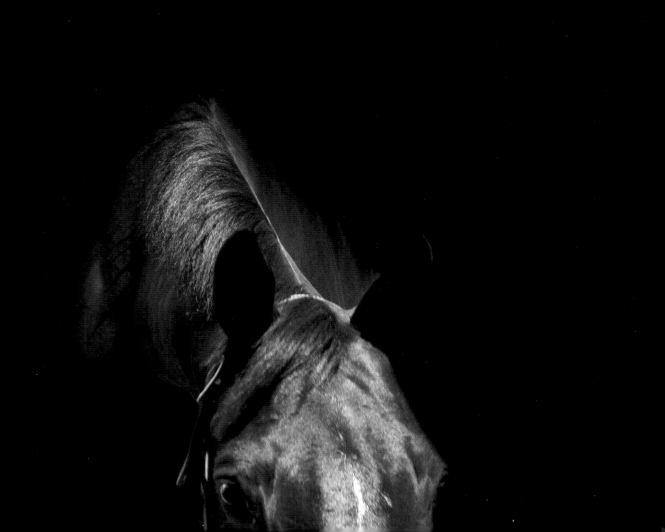

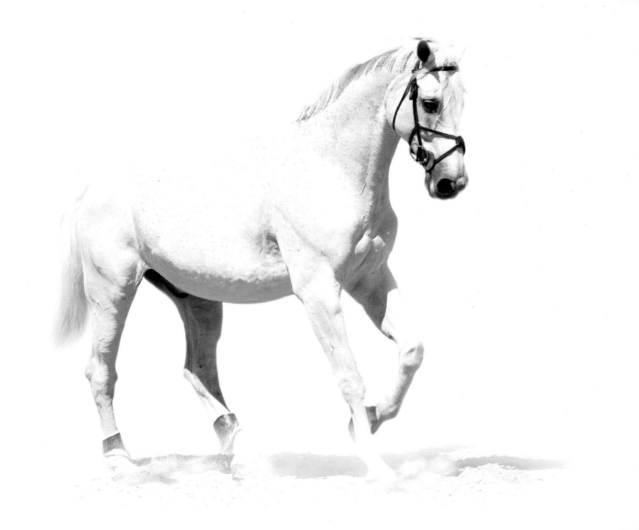

Horses teach us that no emotion is good or bad, each is equally useful in providing information to the individual and to the herd. Magic happens when a human partners with a horse. All that is trivial falls away, and through the sweetness of heightened awareness one sees the self with the broader vision of the horse. If you have never seen yourself reflected back in the eye of a horse, perhaps you have not yet found the vision God has of you.

Carol J. Roush
Master Instructor
Equine Facilitated Human Development

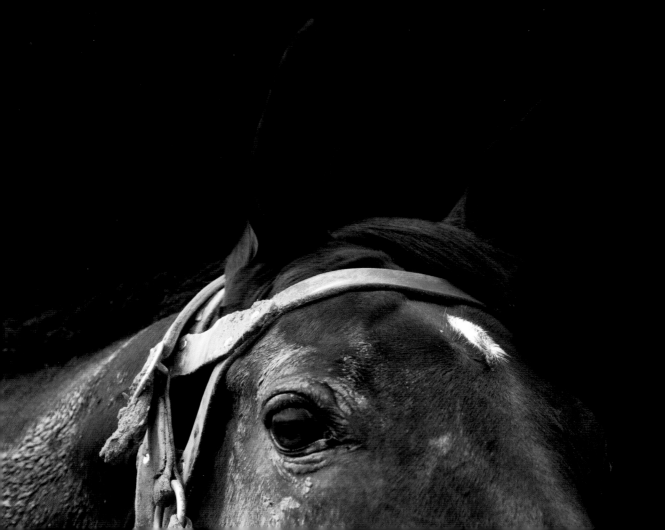

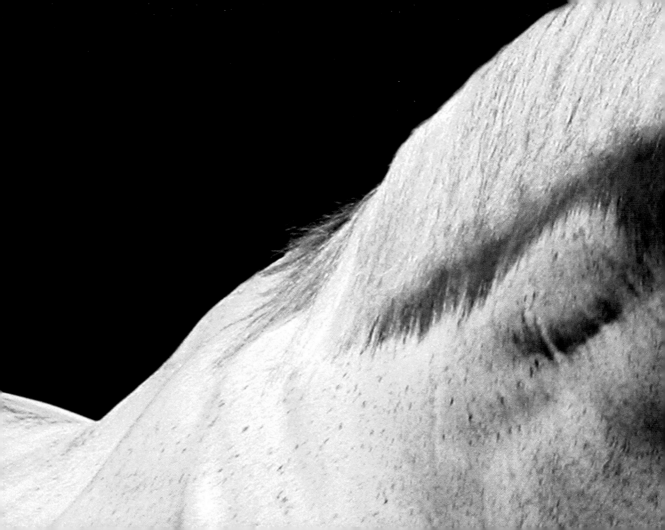

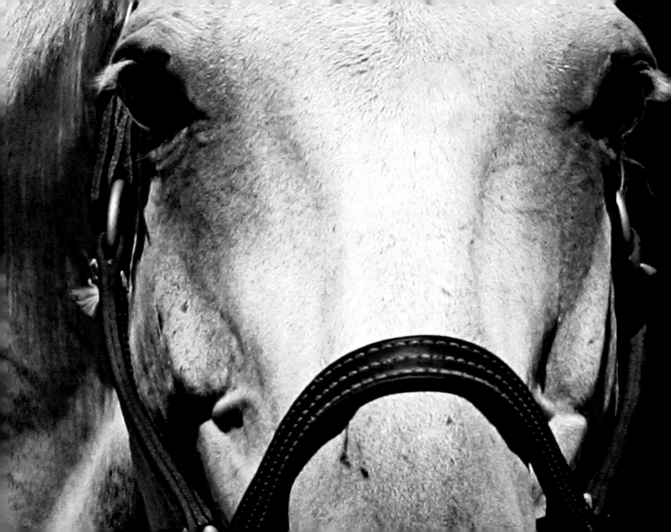

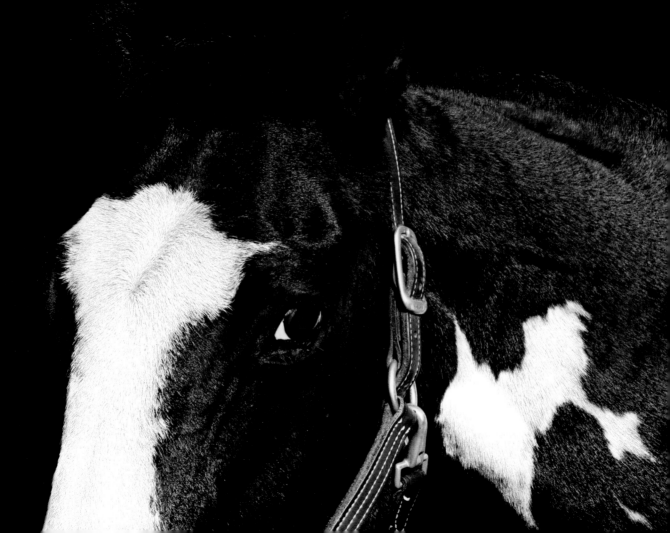

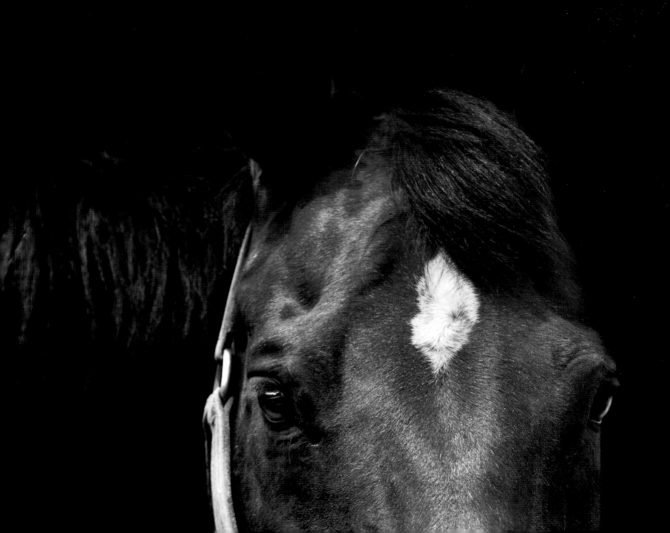

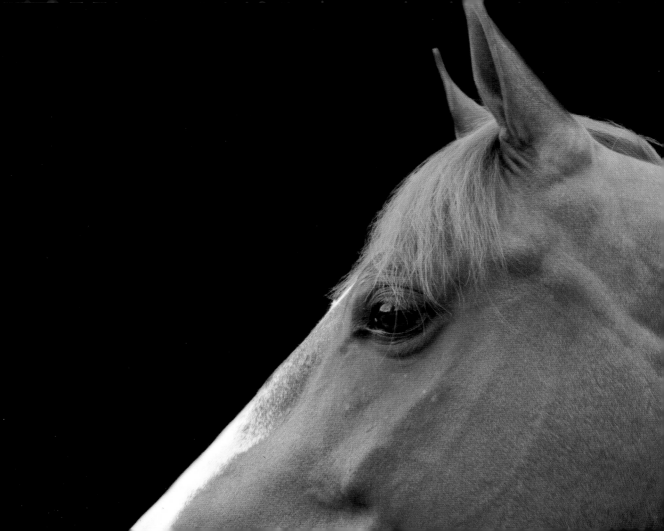

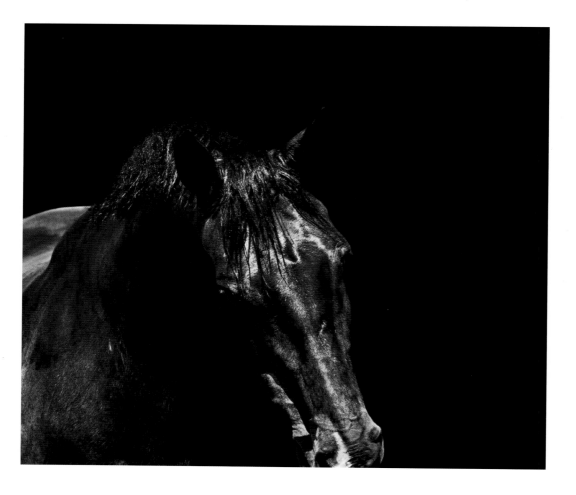

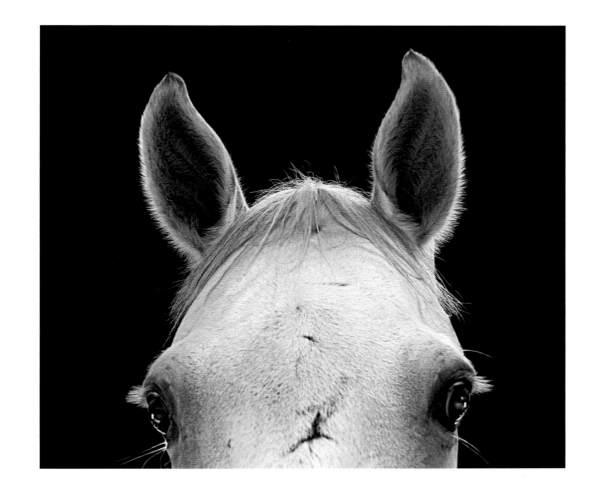

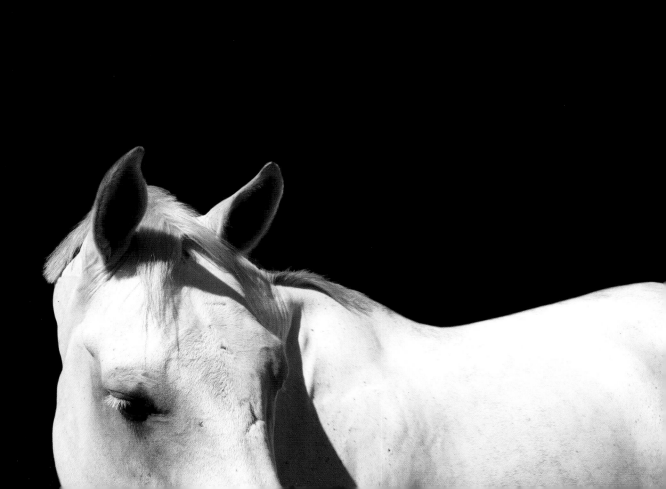

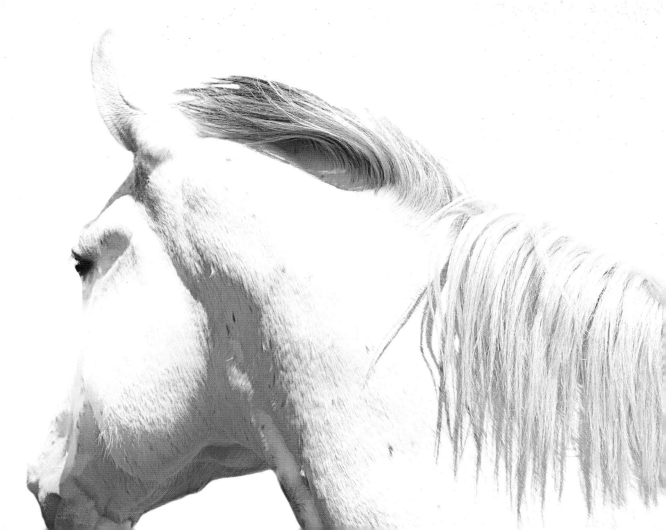

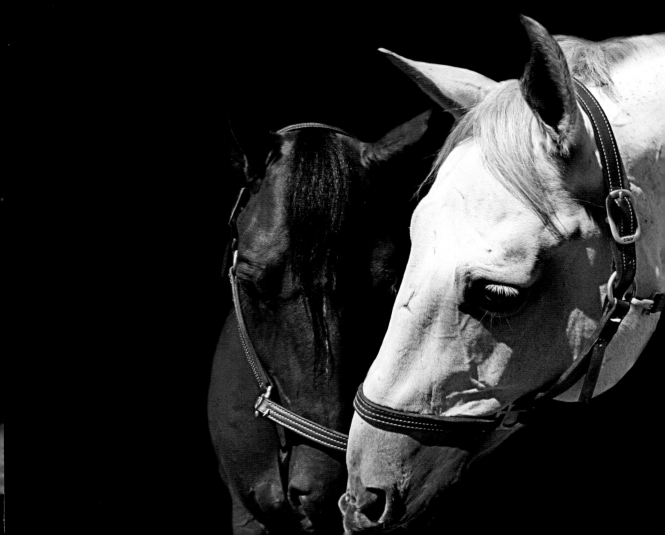

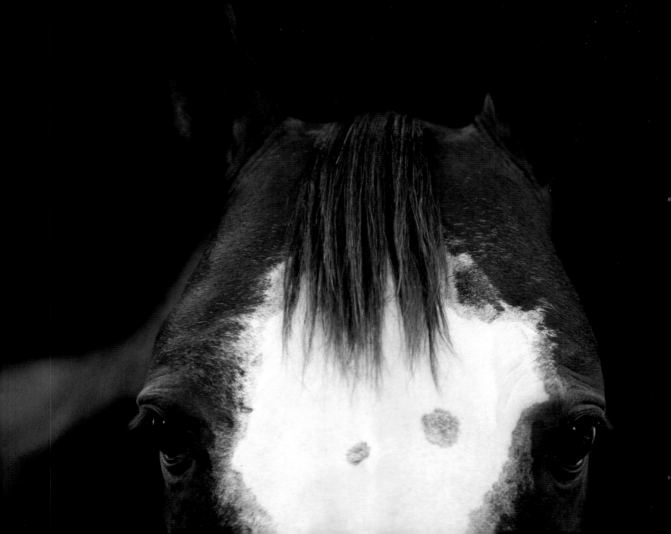

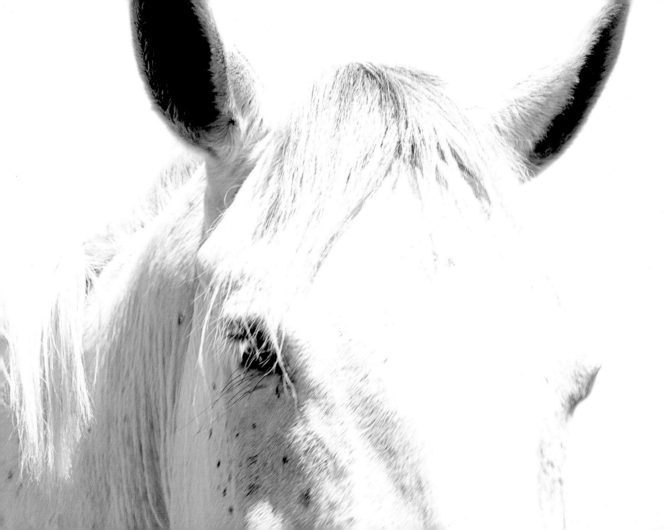

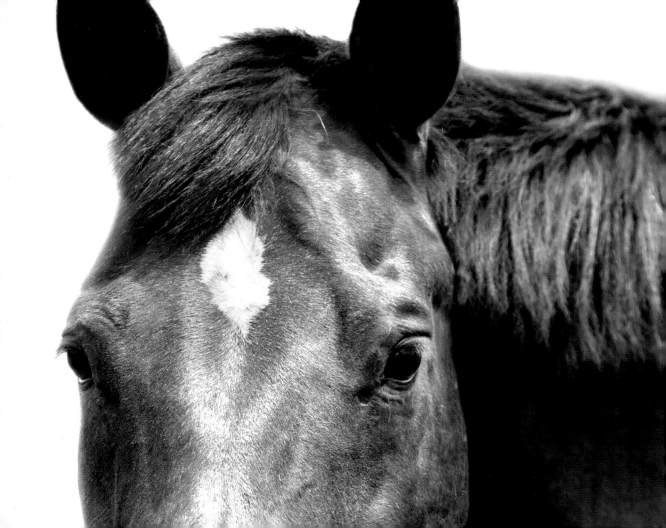